The Project Book - Cartooning Volume 2

(c) Mcleay Workshops 2013

CONTENTS

Zombies Of Awesomeness - 3
Alien Game Show - 7
Angry Mean Sausage - 11
Fart Day - 15
The Magic Button - 19
Bees 'n Bears - 23
Morman The Mammoth - 27
Mr Ninja - 31
Transport Taxi - 35

Projects developed then crafted by Rob Mcleay

Rob Mcleay Publishing/ Auckland A division of Mcleay and Co. Ltd

First Published 2013 by Rob Mcleay Publishing

(c) Rob Mcleay 2013/ Mcleay Workshops™

All rights reserved.

ISBN-13: 978-1492863717

ISBN-10: 1492863718

ALL RIGHTS RESERVED. This book contains material protected under International and Federal Copyright Laws and Treaties. Any unauthorized reprint or use of this material is prohibited. No part of this book may be reproduced or transmitted in any form or by any means, electronic or mechanical, including photocopying, recording, or by any information storage and retrieval system without express written permission from the author / publisher.

I'm Rob Mcleay founder of Mcleay Workshops™, thanks for purchasing our Mcleay Workshops™ Project Book, the best way to get the most out of this book is to attend a Mcleay Workshop™ Cartooning class. Of course anyone who does purchase this book can also still have a go and get a great amount of enjoyment out of it. Have fun and enjoy. Be sure to visit and sign up to our website for extra content such as videos and downloads.

www.mcleayworkshops.com
Rob Mcleay - Founder

ZOMBIE'S OF AWESOMeNESS!

In today's epic ZOMBIE project, design your very own walking dead creature! Study the zombified version of Harry below and incorporate the ideas into your own character.

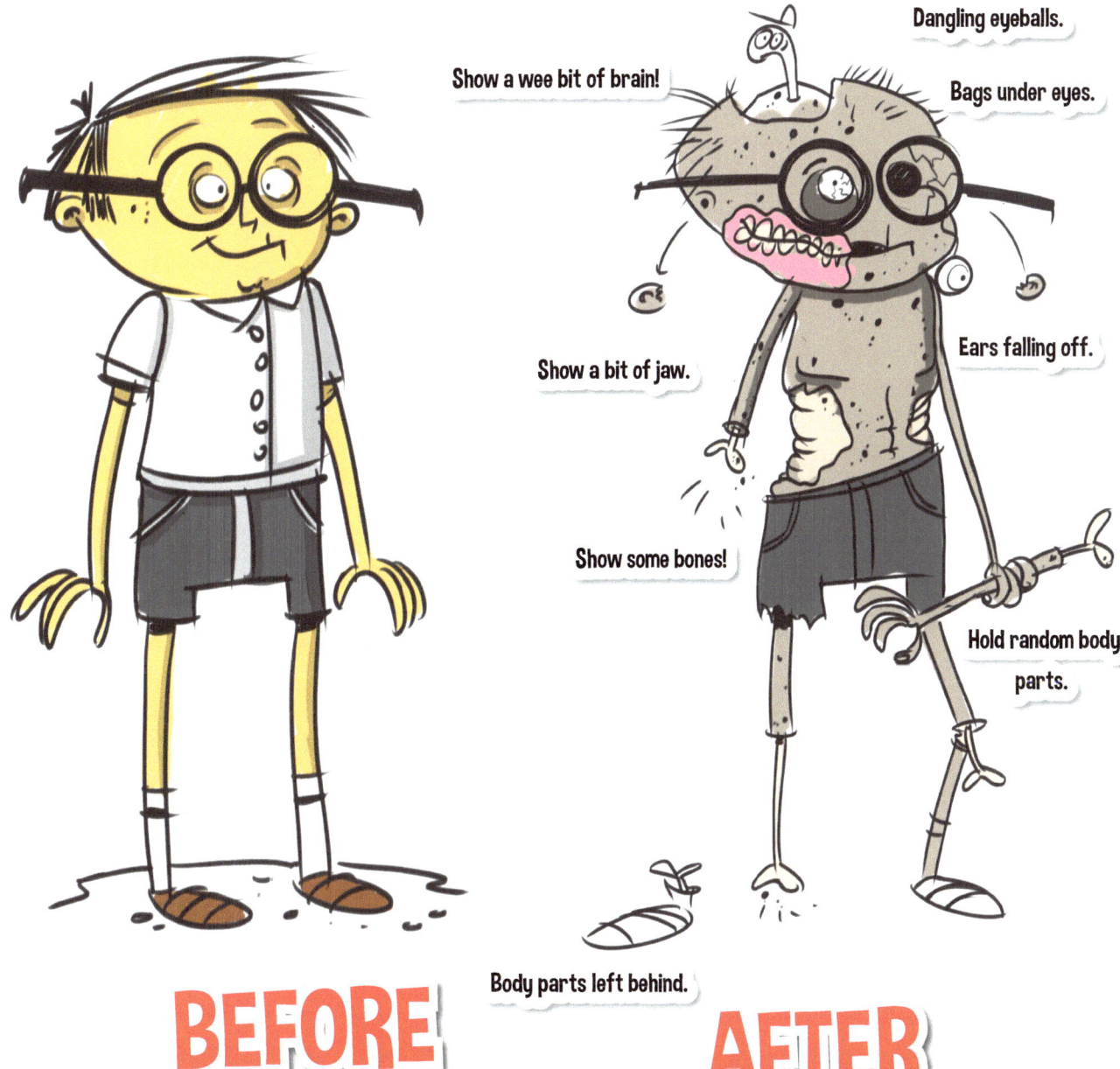

BEFORE / AFTER

DRAW ZOMBIE HARRY

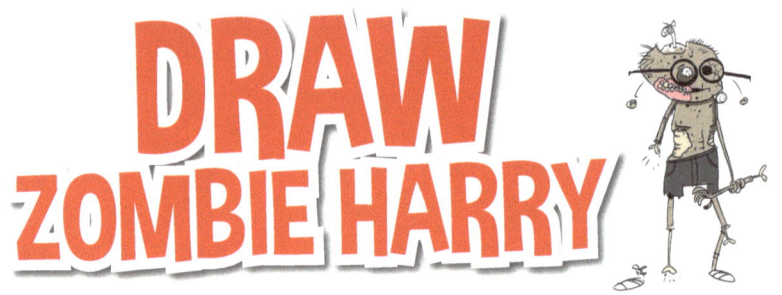

Let's learn to draw Zombie Harry!

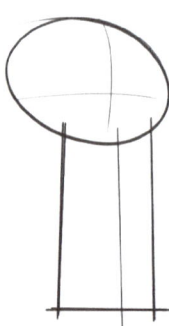

Start with an oval for the head and a rectangle for the torso.

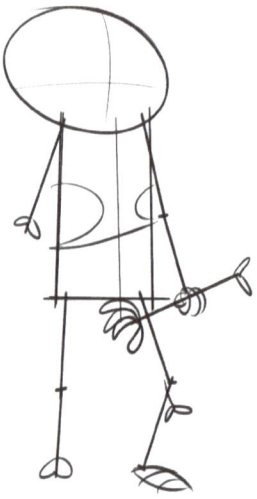

Draw in lines for your limbs, take note of where each limb starts.

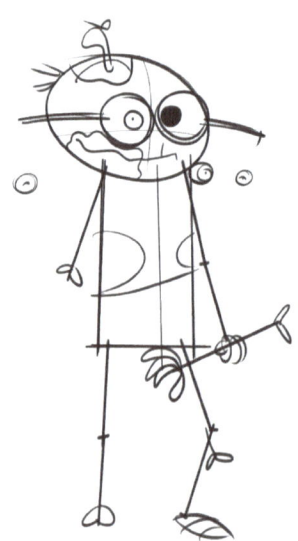

Add a few special effects on Harry's face. Ears have just fallen off!

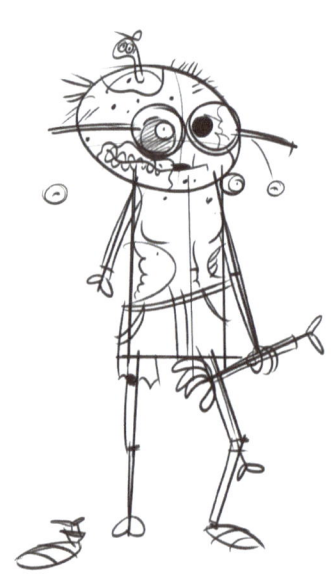

Now finish off with a whole bunch of detail. Fun times!

DRAW YOUR OWN ZOMBIE COMIC!

Have you ever wondered how a normal living creature turns into a Zombie? Then think no further my friend! This is how it happens. Design your own Zombie making comic just like the one below.

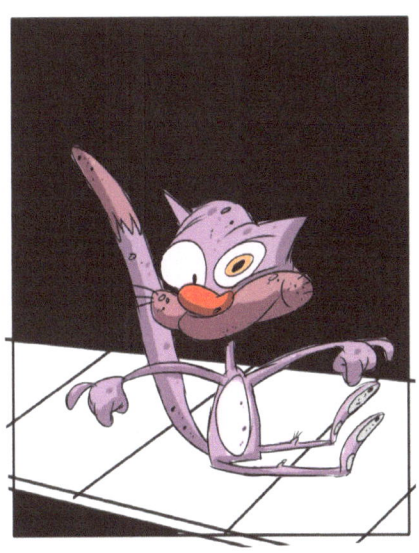
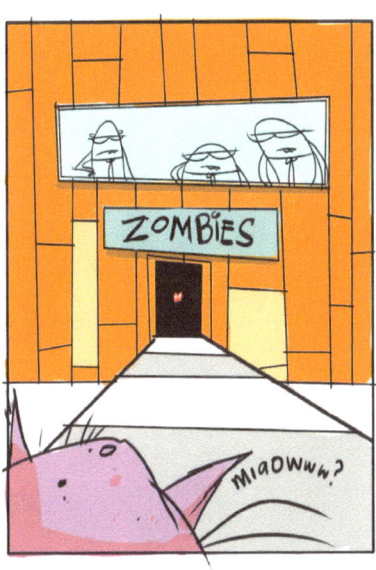

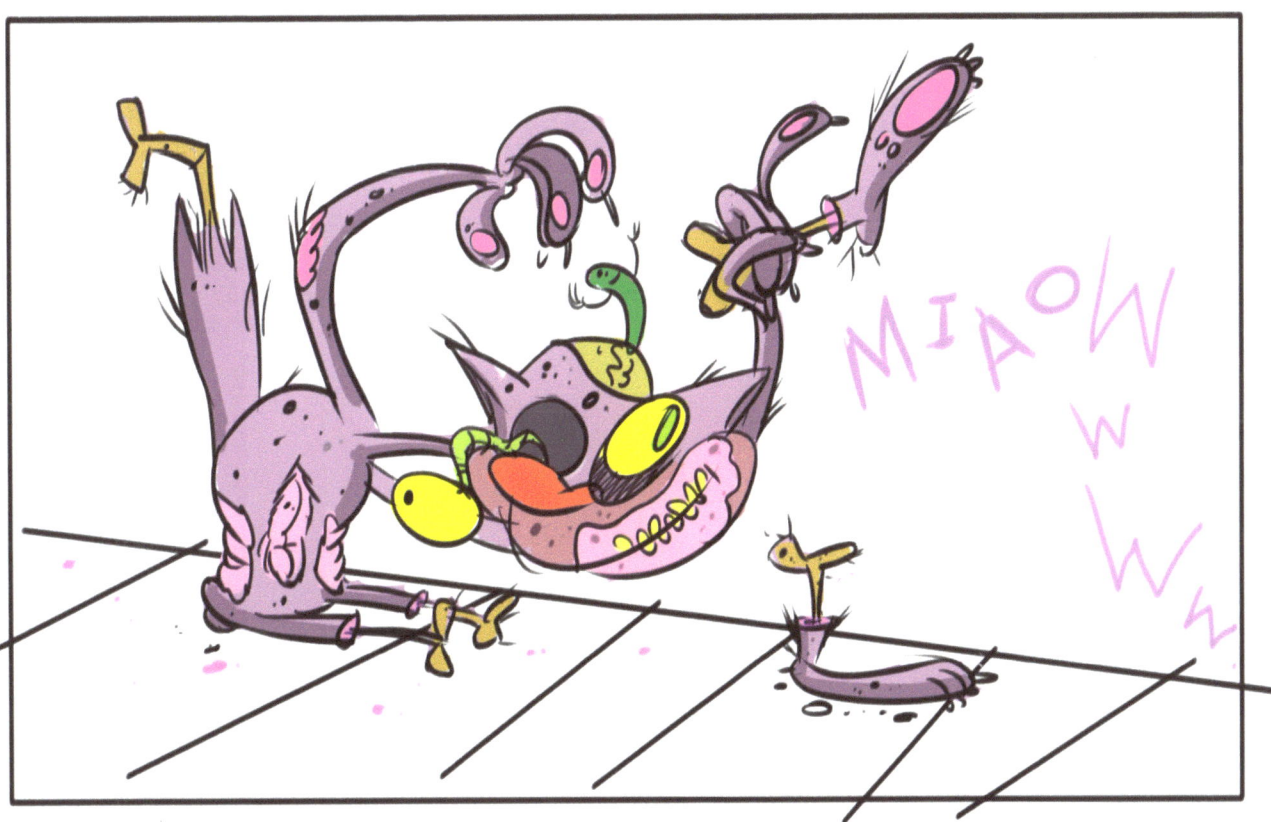

DRAW A ZOMBIE POSTeR!

Attention all Zombie's! An epic new feature film called Zombie's Are Us need some "fresh" new faces for possible acting gigs, call Joe on 555 ZOMBIE for more info. We also need someone to design the movie poster, is this you?

ZOMBIES Are Us!

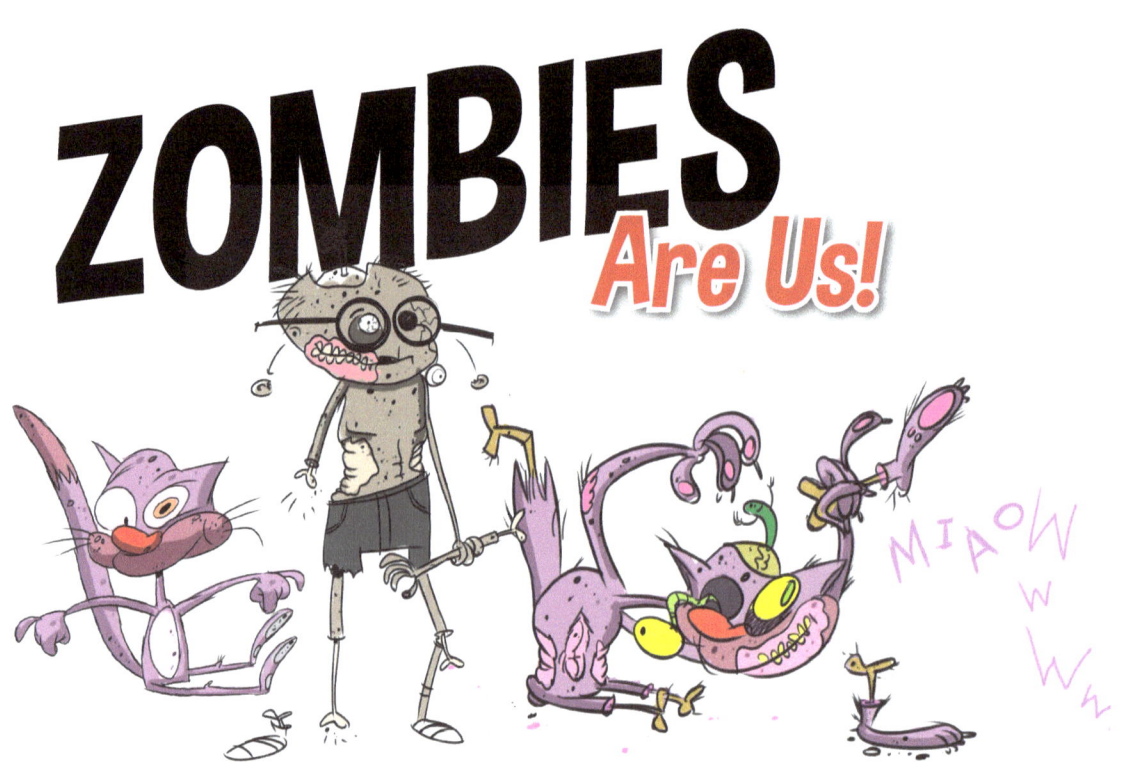

Mr Cat lives in a peaceful suburban town, complete with a family, soft bed and constant supply of catnip. He thought everything was perfect until one day, he got snatched by a team of scientists to be tested on some new viral medication but something went terribly wrong! And poor old Mr Cat was now a.......

ZOMBIE CAT
COMING SOON TO A THEATRE NEAR YOU!

STARRING ZOMBIE HARRY AS "ZOMBIE HARRY" AND ZOMBIE CAT AS "ZOMBIE CAT!"

ALIEN GAME SHOW!

Thanks for joining us on Alien Game Show! Below are your contestants but we need three more.

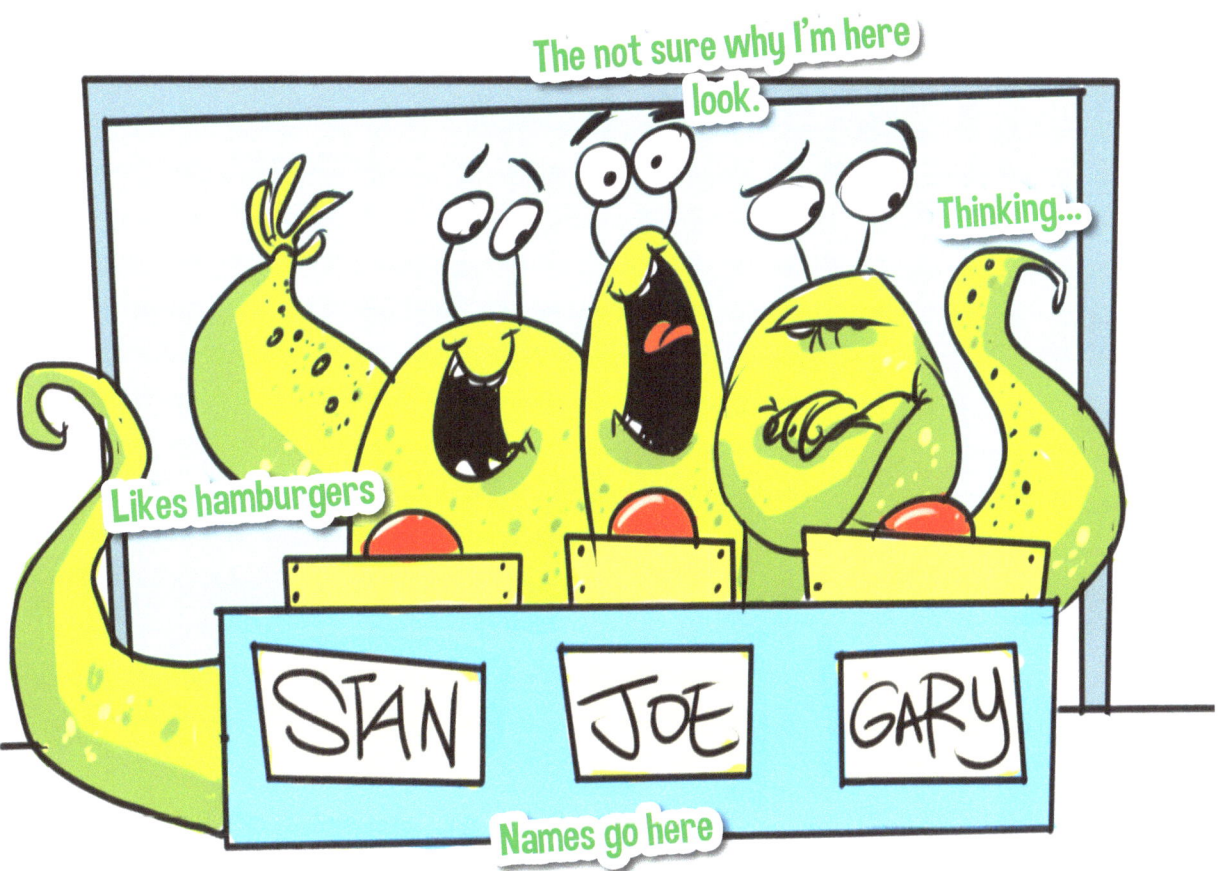

The not sure why I'm here look.

Thinking...

Likes hamburgers

Names go here

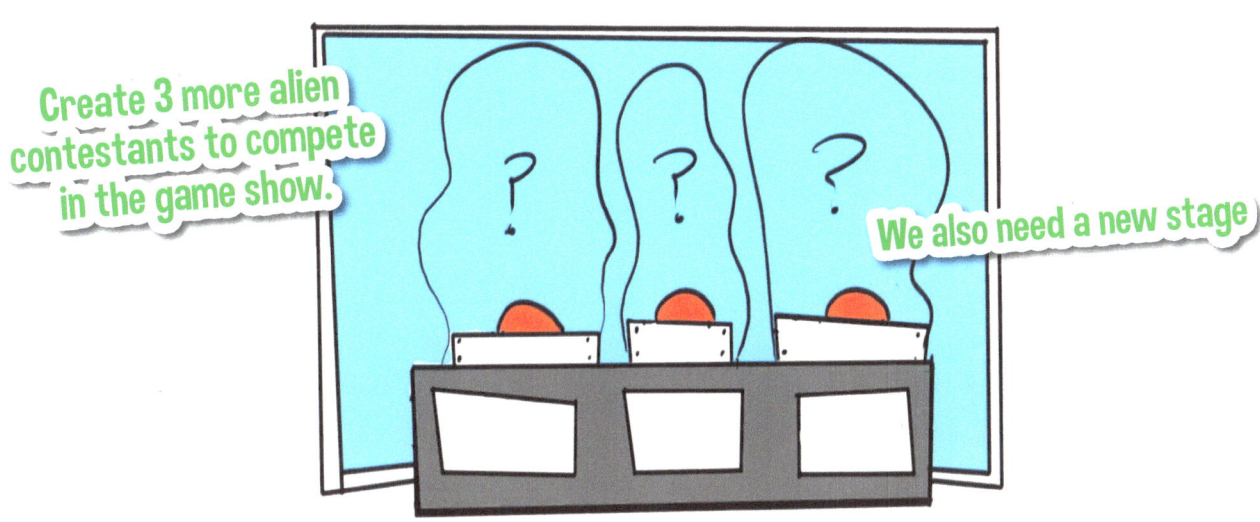

Create 3 more alien contestants to compete in the game show.

We also need a new stage

YOU WIN A FAB PRIZE!

And this is what you win! Your personal Robot Slave. Your mission is to design 2nd and 3rd prize for the losers, make them real useless. If you have time design a new podium for your prize to be paraded on. Don't forget the lights!

Joy! 1st Prize

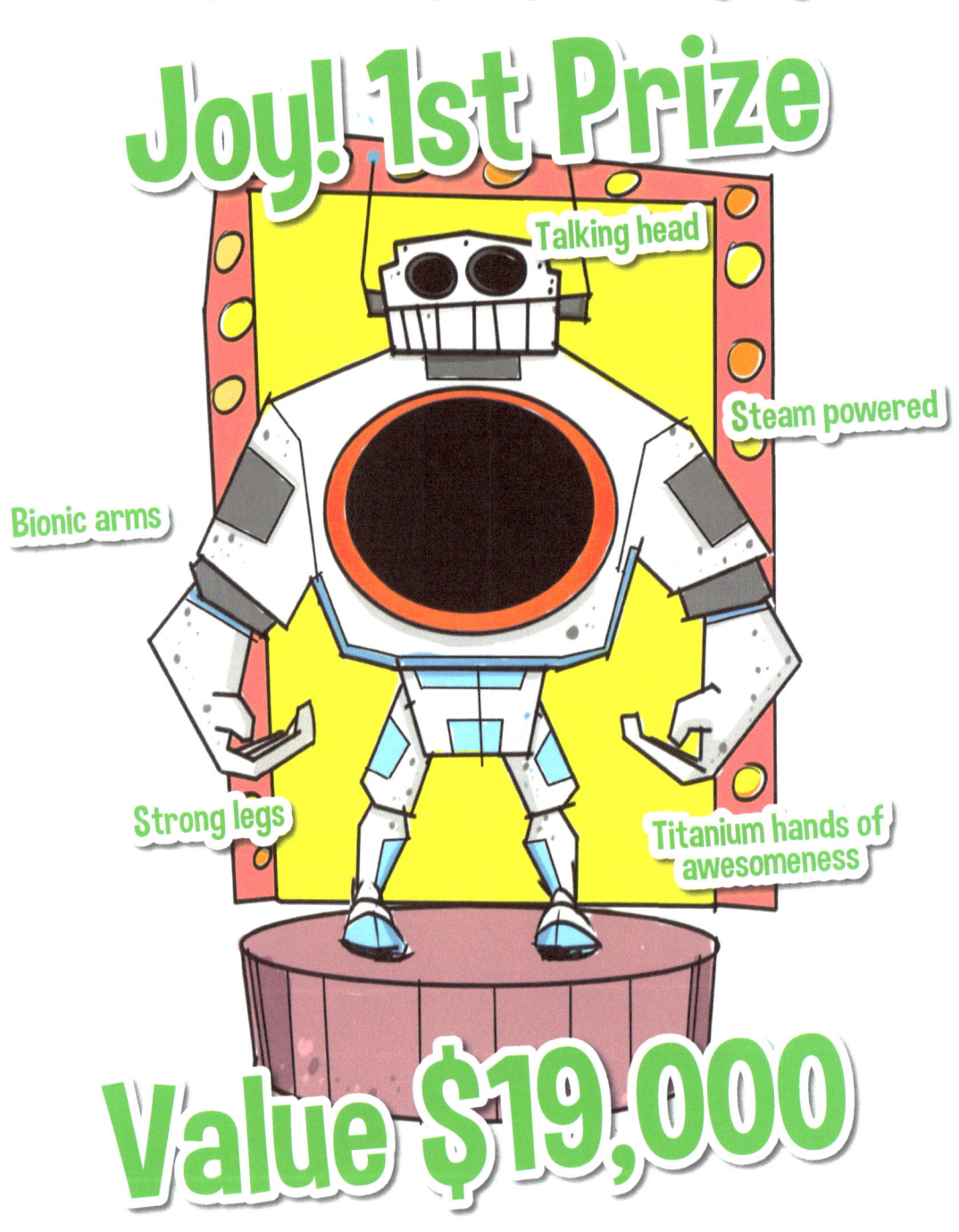

- Talking head
- Steam powered
- Bionic arms
- Strong legs
- Titanium hands of awesomeness

Value $19,000

YOU'VE BEEN GOOED!

This poor alien lost, so now he's going to get gooed! Create your own goo dispenser.

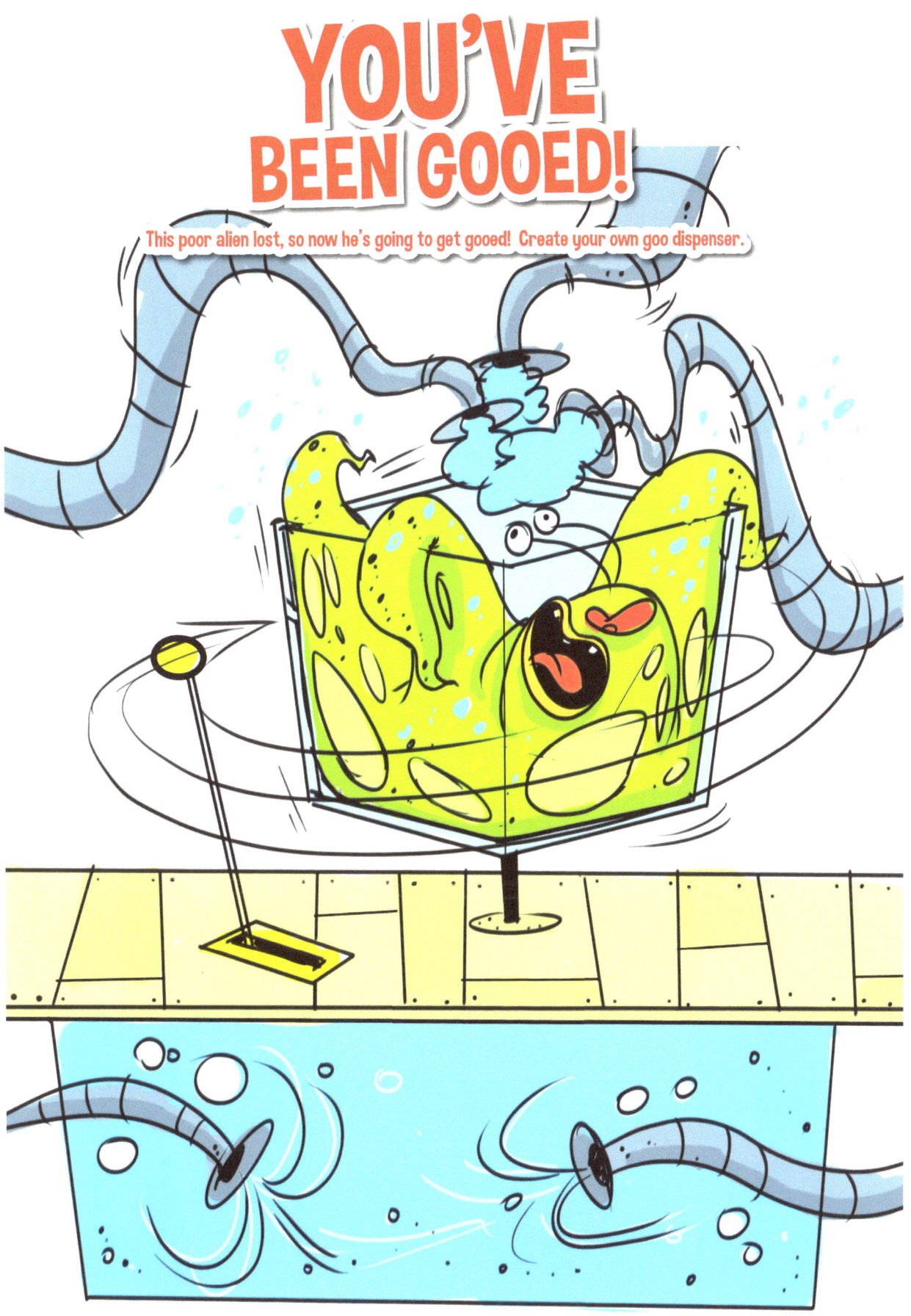

LET'S DRAW AN ALIEN!

Follow the steps to create your very own alien.

Begin with your main body shape and then an oval for the mouth.

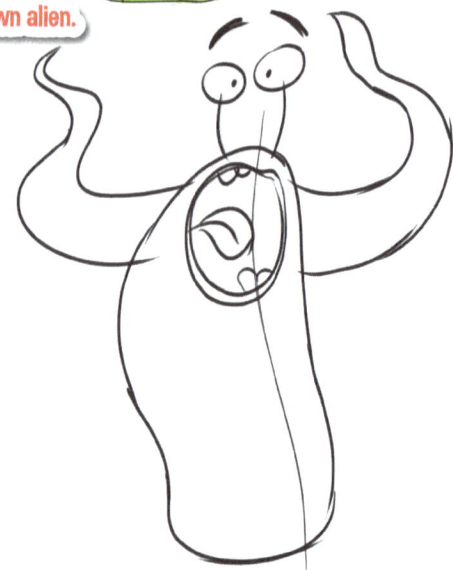

Add some slimey arms, your tongue and a few eyeballs

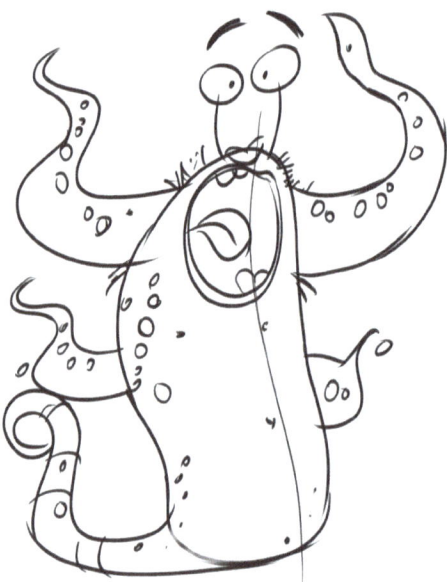

Add some more tentacle like limbs and then some spots.

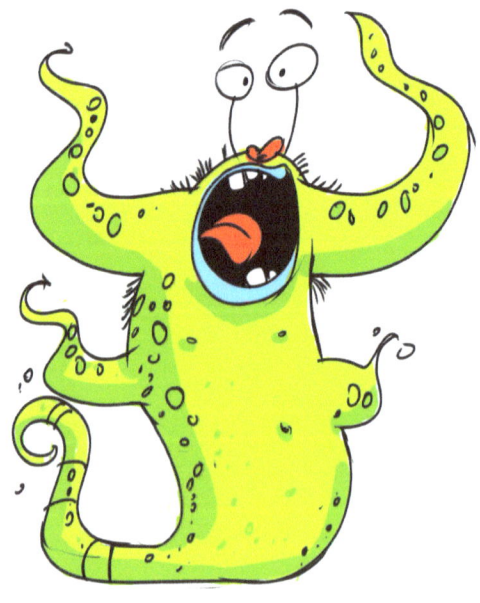

Now colour that sucker in!

ANGRY MEAN SAUSAGE!

Angry mean sausage has escaped from the hot dog bun. - What happens next? (See empty panel)

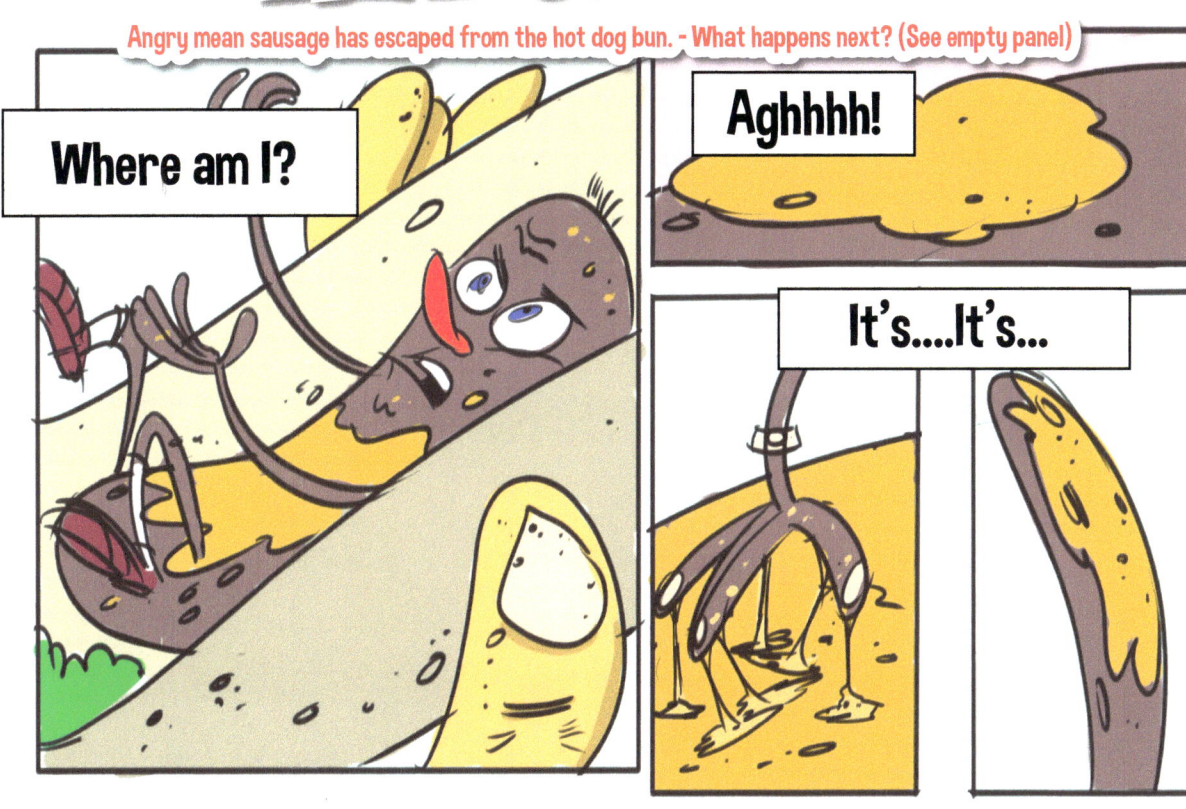
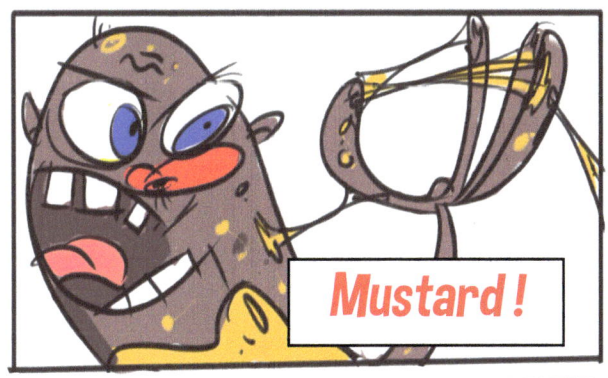
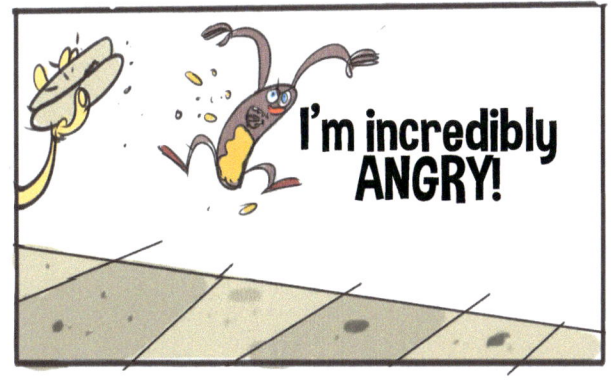

ANGRY MEAN SAUSAGE FACeS!

Types of Angry Mean Sausage faces - have ago drawing them.
Challange. Change the disguise of your sausage.

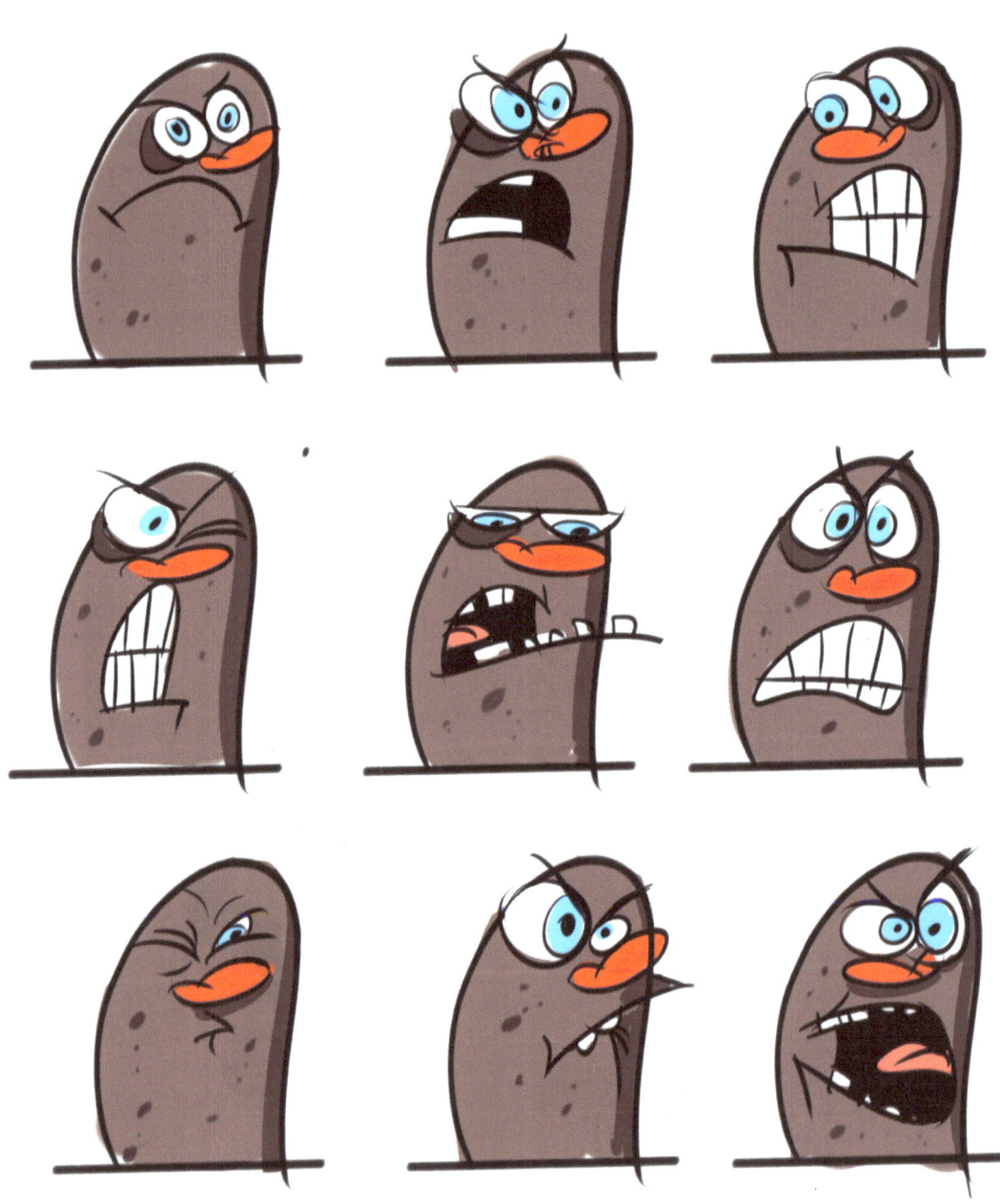

ANGRY MEAN SAUSAGE CHASE SCENE!

Draw your Angry Mean Sausage bouncing through the streets in this storyboard. Read the notes provided and finish of each drawing.

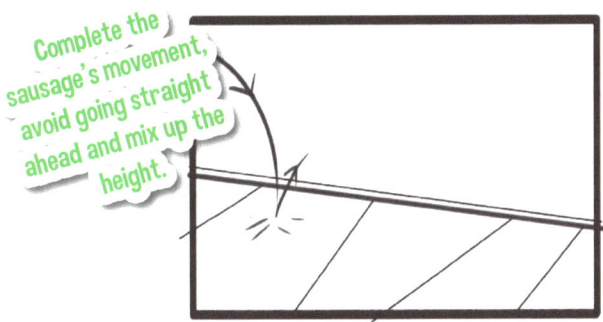

Angry Mean Sausage bounces wildy through the streets..

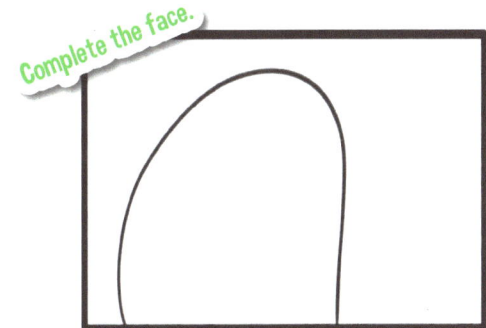

He looks angrily into the camera!

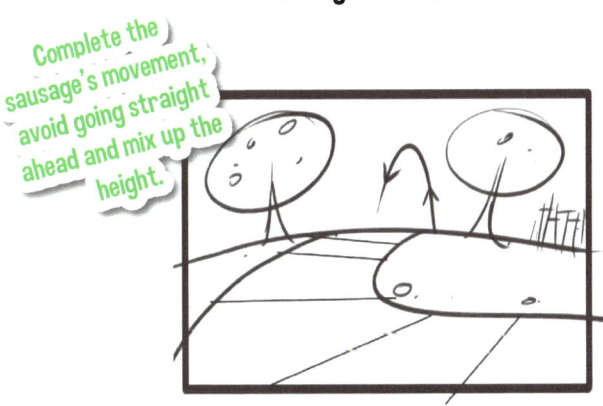

Angry Mean Sausage bounces wildy through a beautiful park...

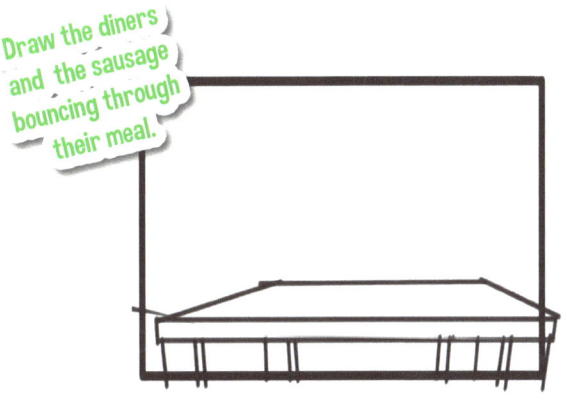

On to a cafe table, two diners watch in disbelief!

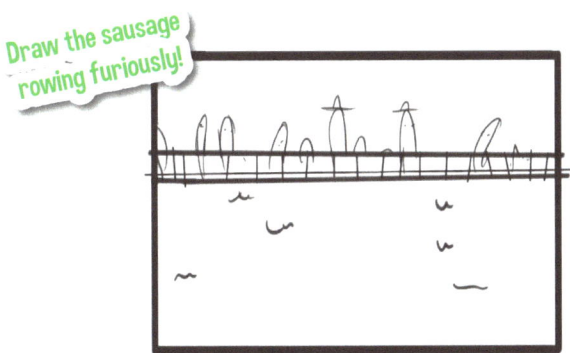

Angry Mean Sausage lands in a boat and rows furiously though a canal...

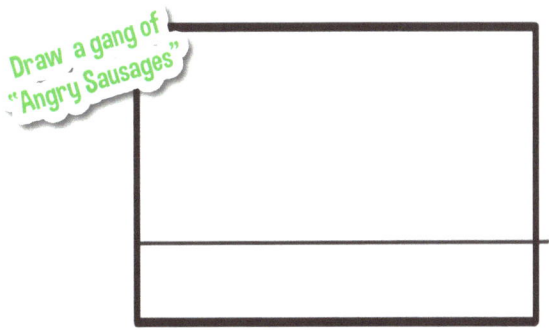

Finds a gang of angry sausages to join.

ANGRY MEAN SAUSAGE IN MOTION!

Learn to draw Angry Mean Sausage

Draw a baked bean.

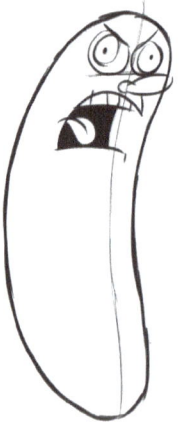

Now add an angry face. Arggh.

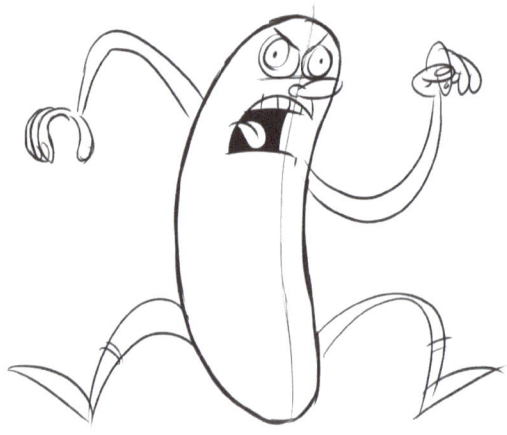

Draw in some arms and legs.

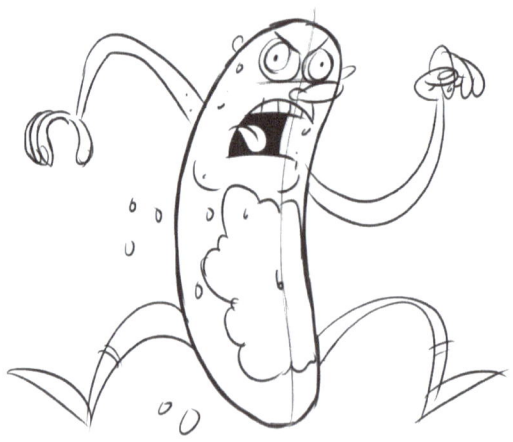

Slather on some mustard and what do you have? An Angry Mean Sausage!

FART DAY!
CATCH THE FART VIRUS

A nasty bug is doing the rounds at Mr Gorilla's work. this means he has to get his Anti Stinky Bum needle jab today

THE FART NEEDLE
MAKE SURE IT'S SHARP!

Design 3 types of needles "Small, medium and MEGA large..." Give each needle a molecular breakdown of it's contents, how to operate it and the amount of damage it may do to the flatulence virus.

Let's get this hyperdermic ho-down started!

Anti Fart Flavoured — May not taste like fart.

Snot — Contains snot enhanced bacterium, apply 1 dose anywhere.

Bubblegum Anti Virus — Contains extracts of bubblegum and candy, apply 2 doses on rear end.

THE FART VIRUS
WHAT DOES IT LOOK LIKE?

Create a fart virus then have him/her playing a musical instrument.

STRUM!

TAP, TAP, TAP

HOW TO DRAW MR GORILLA

Draw Mr Gorilla here.

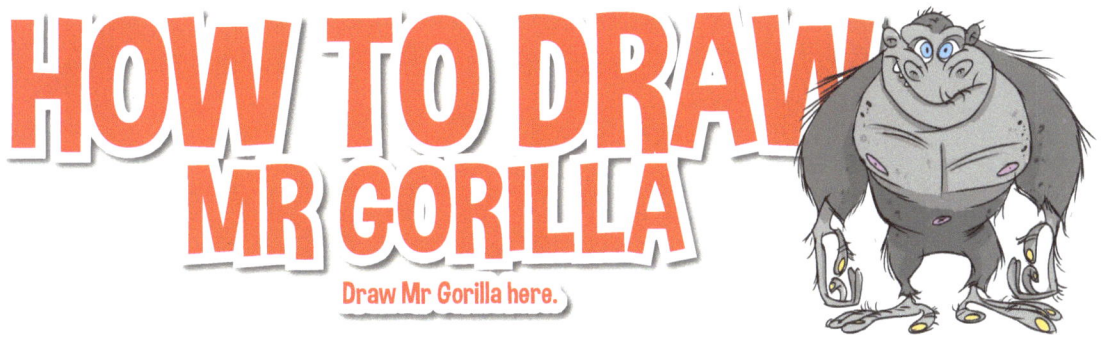

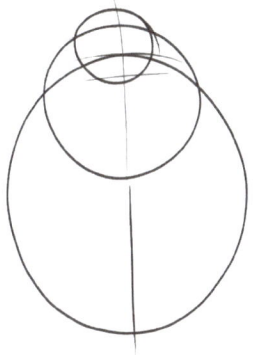

Draw the 3 shapes shown above.

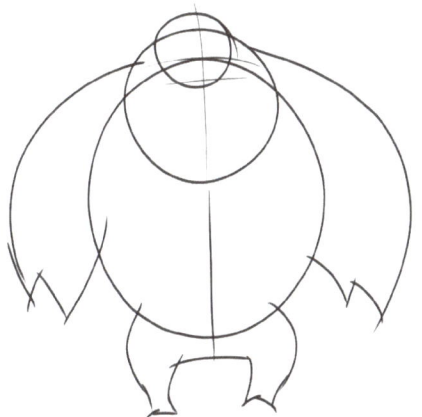

Add the arms and legs.

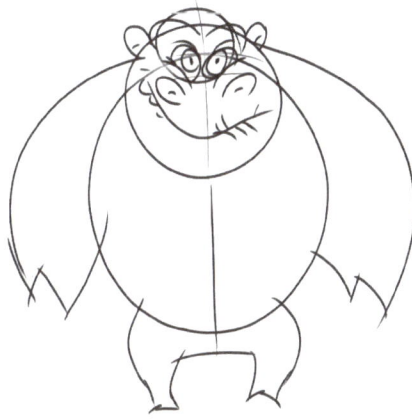

Draw in some facial features.

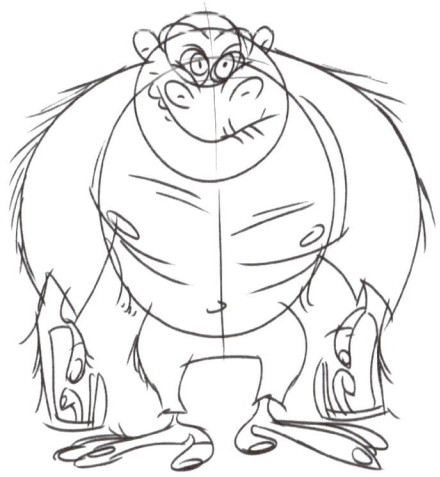

Finish off the hands, feet and detail.

MR GORILLA DON'T LIKE NEEDLES!

Create four ways to get Mr Gorilla to get his bum jabbed.

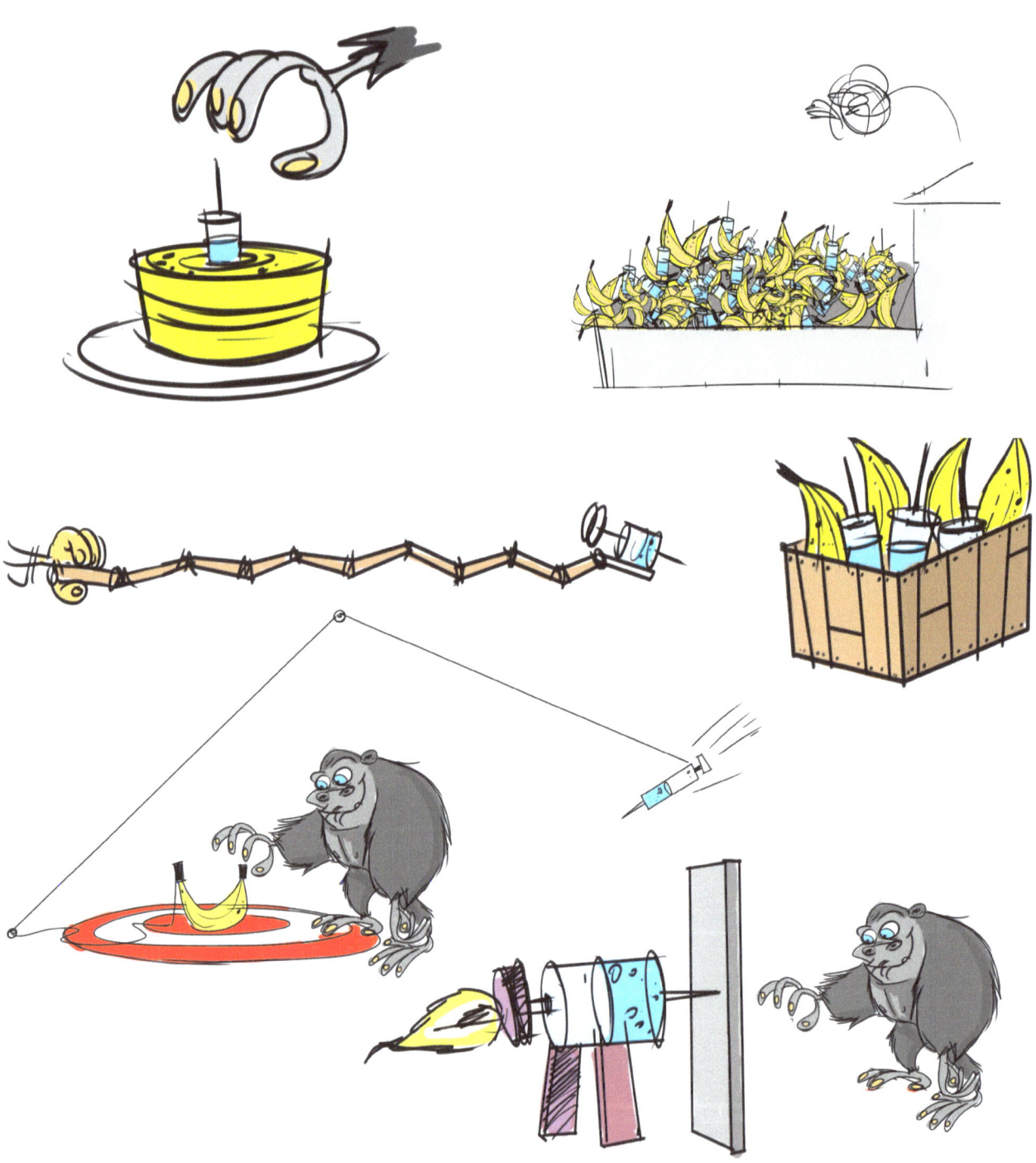

iDEAS FOR YOUR EPIC DRAWING

HERE ARE A FEW IDEAS TO HELP YOU DRAW THE 'EPIC BUTTON PUSHING SCENE"

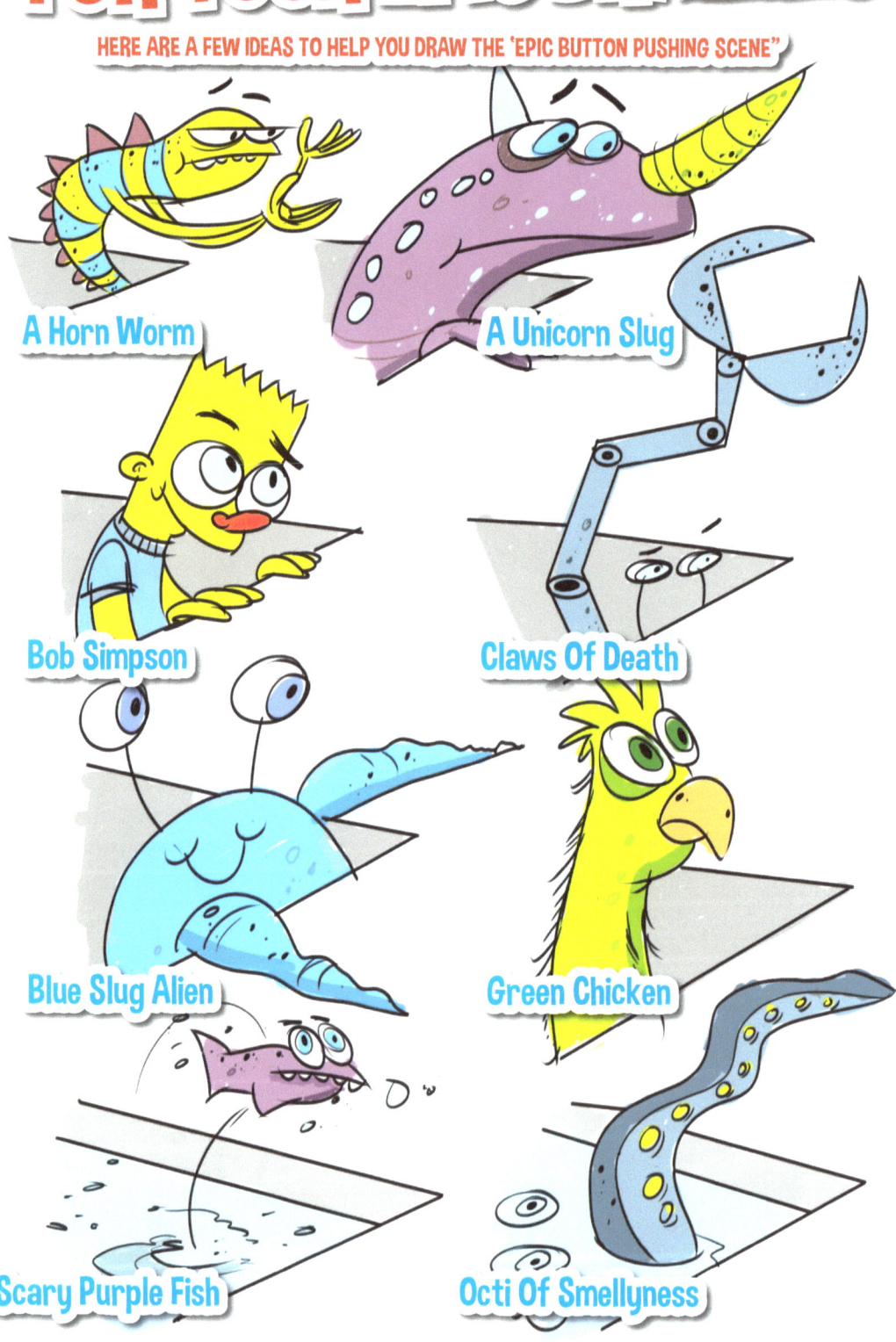

A Horn Worm

A Unicorn Slug

Bob Simpson

Claws Of Death

Blue Slug Alien

Green Chicken

Scary Purple Fish

Octi Of Smellyness

DRAW DAVE

They're ugly, a little bit creepy and a little bit crawley but they deserve to be drawn too! Follow the steps to create your cockroaches.

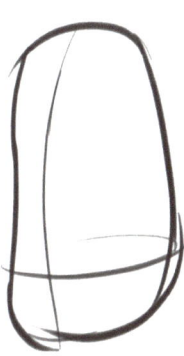

Sketch in a cute little baked bean shape.

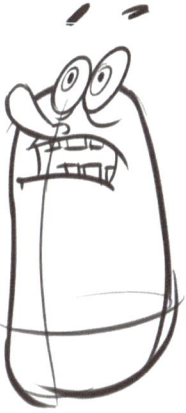

Now you can add the eyeballs, nose and mouth.

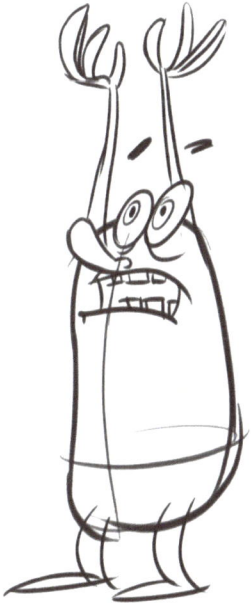

Add the arms and legs.

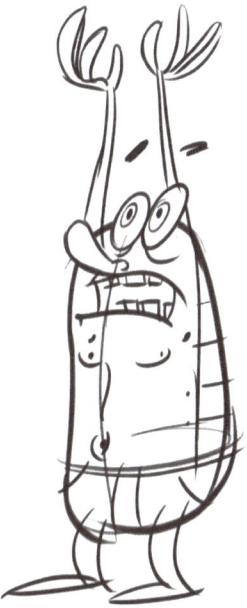

Finish off with some details and voila! You have a SCARED COCKROACH!

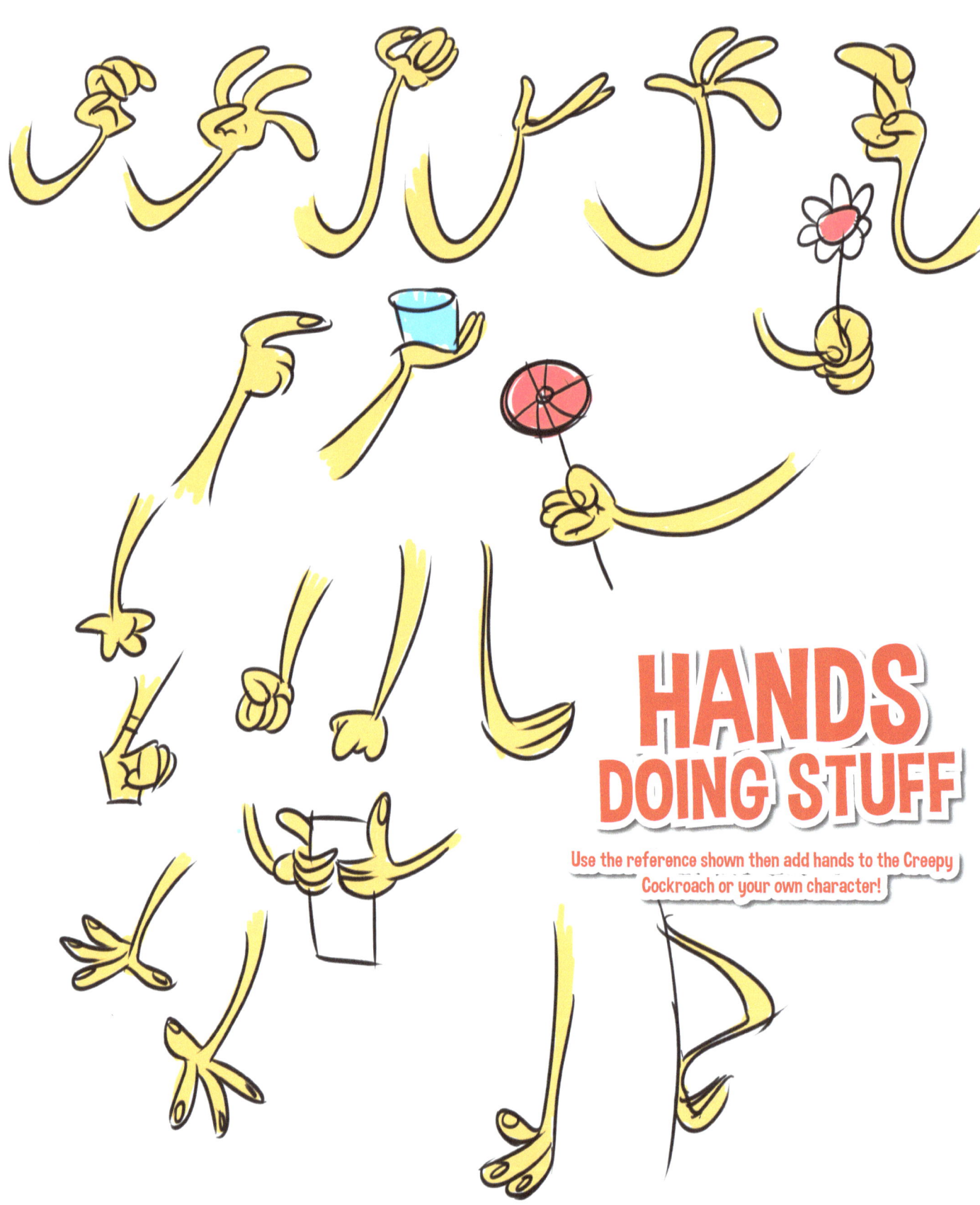

HANDS DOING STUFF

Use the reference shown then add hands to the Creepy Cockroach or your own character!

BEES 'N BEARS
THE HONEY EXTRACTION CONTRAPTION

The local Bear and Bee community in Beebear Town are looking for a Honey Extraction designer for the new development in Bearbee Forest. You will need to design a mechanical beehive unit, a tree honey extraction unit and while you are at it draw your bears 'n bees!

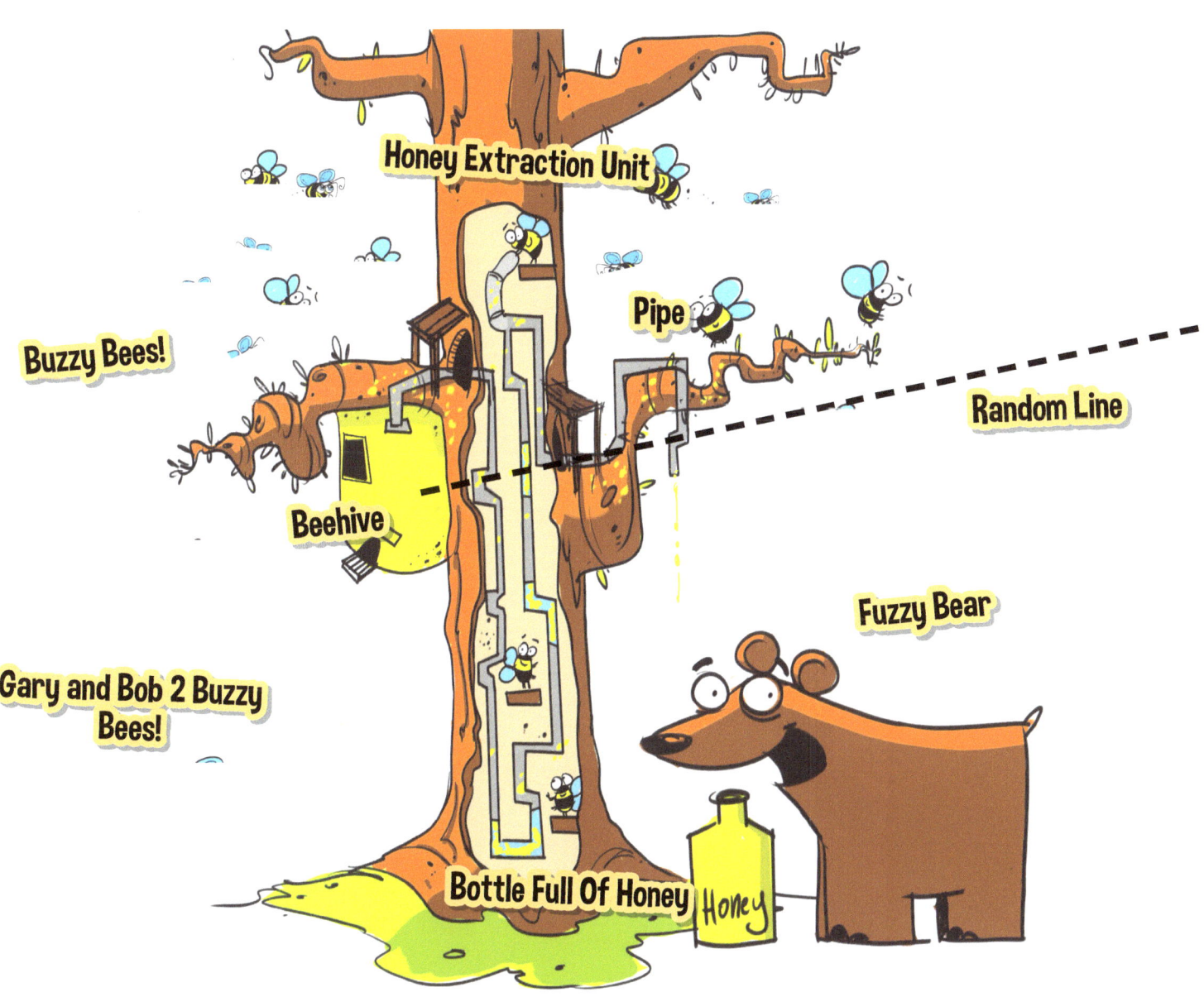

The Beehive

What we don't see...
Design your own Honey Transport Contraption

The Bear

Here is a bear, he's hungry, draw him.

Begin your hungry bear by drawing the head and it's basic shapes, the circle represents it's skull.

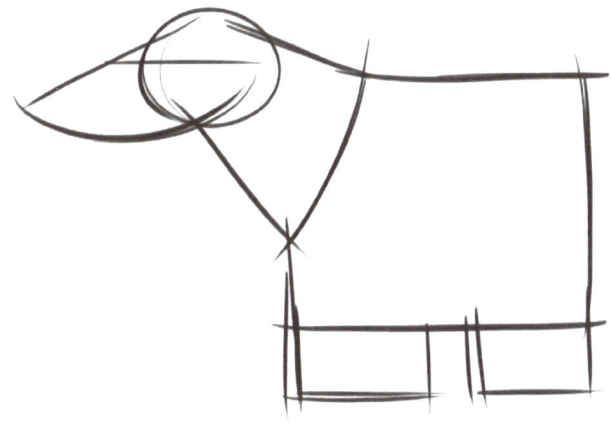

Now draw in the torso and legs, keep 'em chunky!

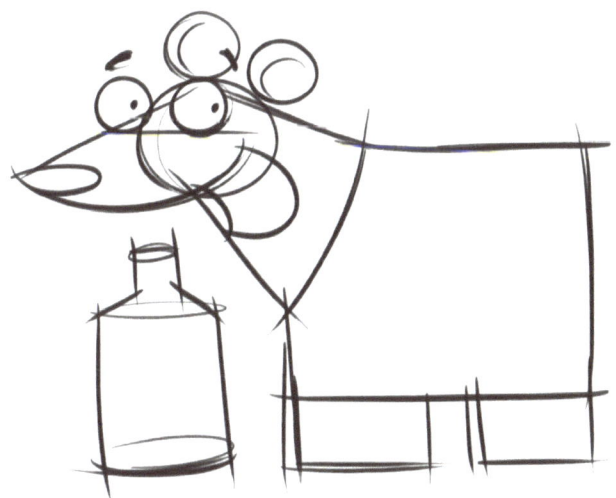

Draw in some eyes, a mouth, ears and the honey pot to collect the lashings of honey!

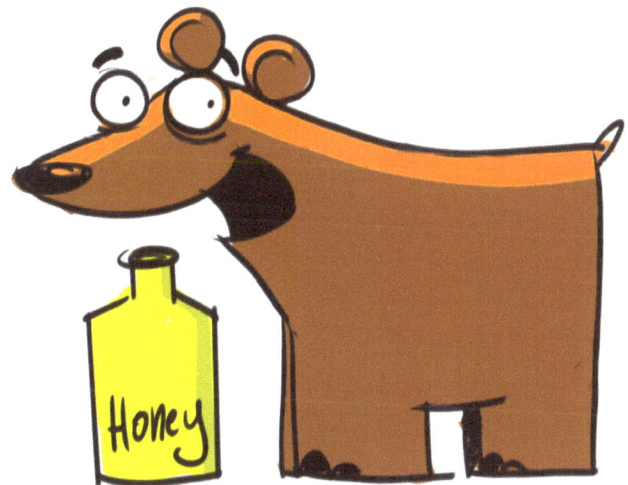

Now colour the poor fella in why don't ya!

The Bee

This wee fella makes the honey that feeds the bear, draw him.

Begin with a basic oval shape with some guide lines for the eyes.

Draw the eyes in and the wings.

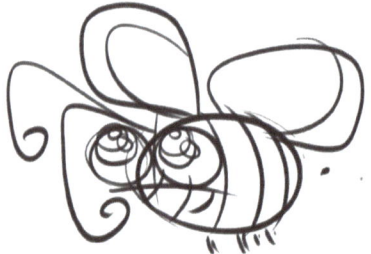

Give the bee some antennas, then draw a few stripes on the wee fella so he feels like a real honey bee!

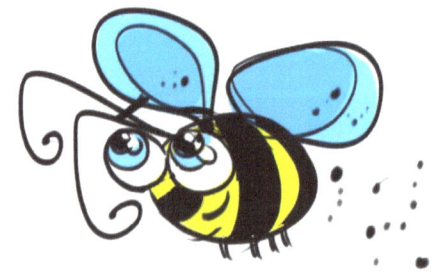

Throw a dash of colour on him to make him feel complete.

MORMAN THE MAMMOTH

Morman the Mammoth has just spotted his favourite fruit - a goossenberry! Oh Joy!
Come up with a magical power that will enable Morman to eat.

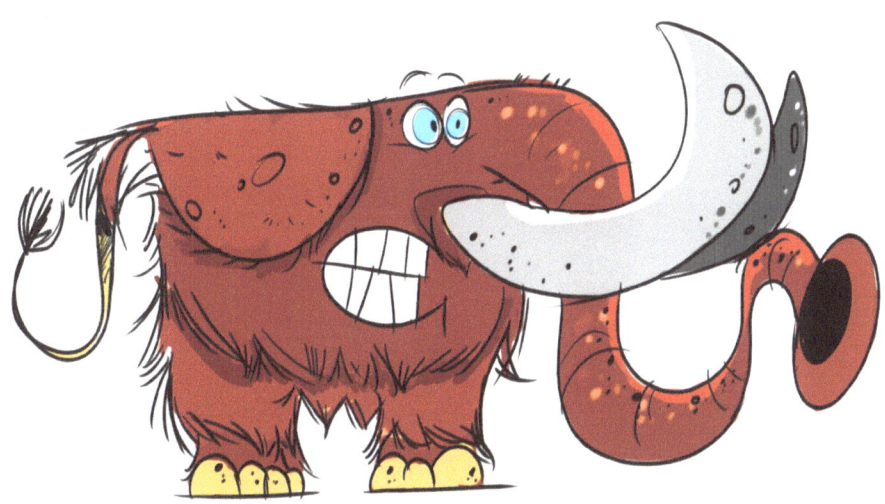

Your Mission

Develop a power of awesomeness that will help Morman achieve his goal of eating his favourite fruit. Come up with four magical abilities, then storyboard your magical ability being used by Morman, each demonstration should be no longer than four panels, see below for examples.

Some Magical Ideas

Elasticity
Self-destruction
Self-liquification
Gaseous form
Growth/shrinking
Self-duplication
Invisibility
Absorbing someone else's powers
Negating someone else's powers
Luck manipulation (good luck for hero and/or bad luck for enemies)
Illusions

Storyboard Layout Idea

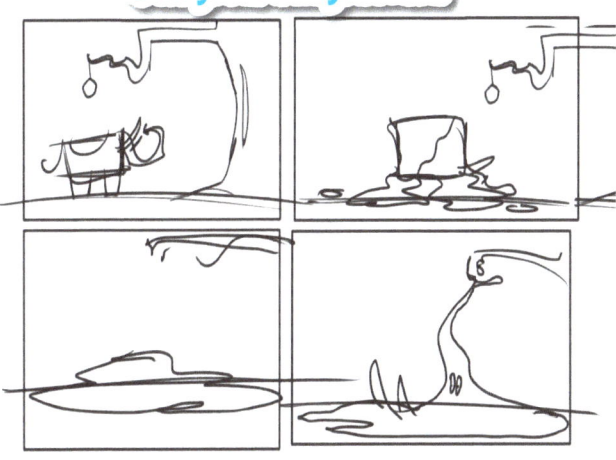

IT'S COMIC TIME WITH SUPER POWERS

Design a comic of your wolly mammoth using his special power!

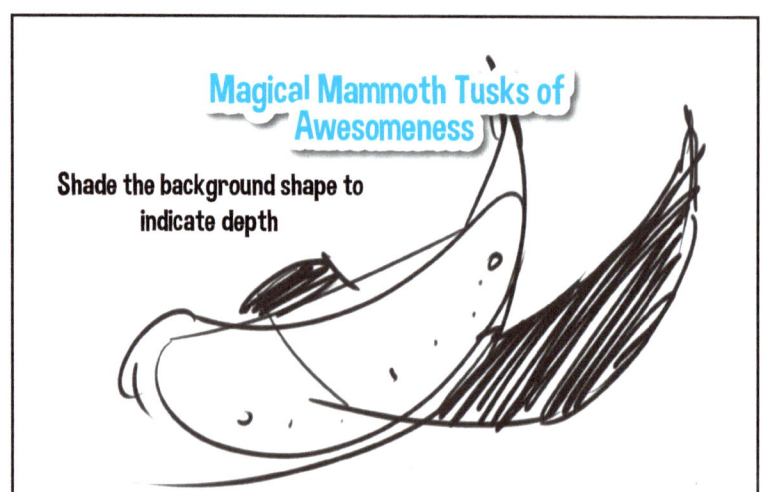

Magical Mammoth Tusks of Awesomeness

Shade the background shape to indicate depth

Add "gaps" between panels

"NOW, IF I CAN JUST REACH..."

"THANK YOU!..."

LET'S DRAW MORMAN THE MAMMOTH

It's time to get your wolly socks on and draw Morman.

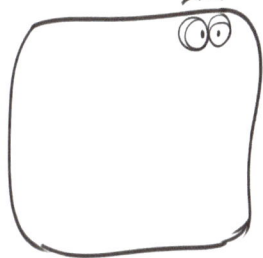

Draw a funny looking square with some eyeballs.

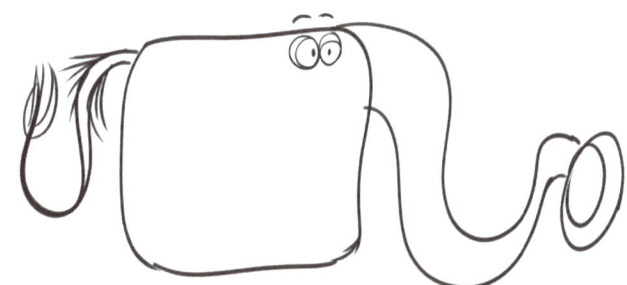

Draw the trunk and tail.

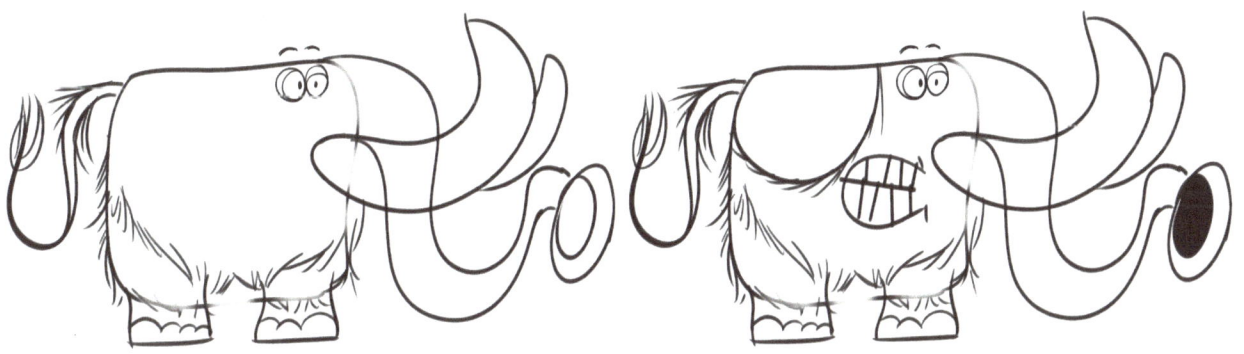

Add your tusks of awesomeness plus feet of epicness.

Finish off with a snarling mouth and floppy ears.

FRUIT CHARACTERS
EAT OR BE EATEN!

Turn these plain old fruit into cartoon characters.

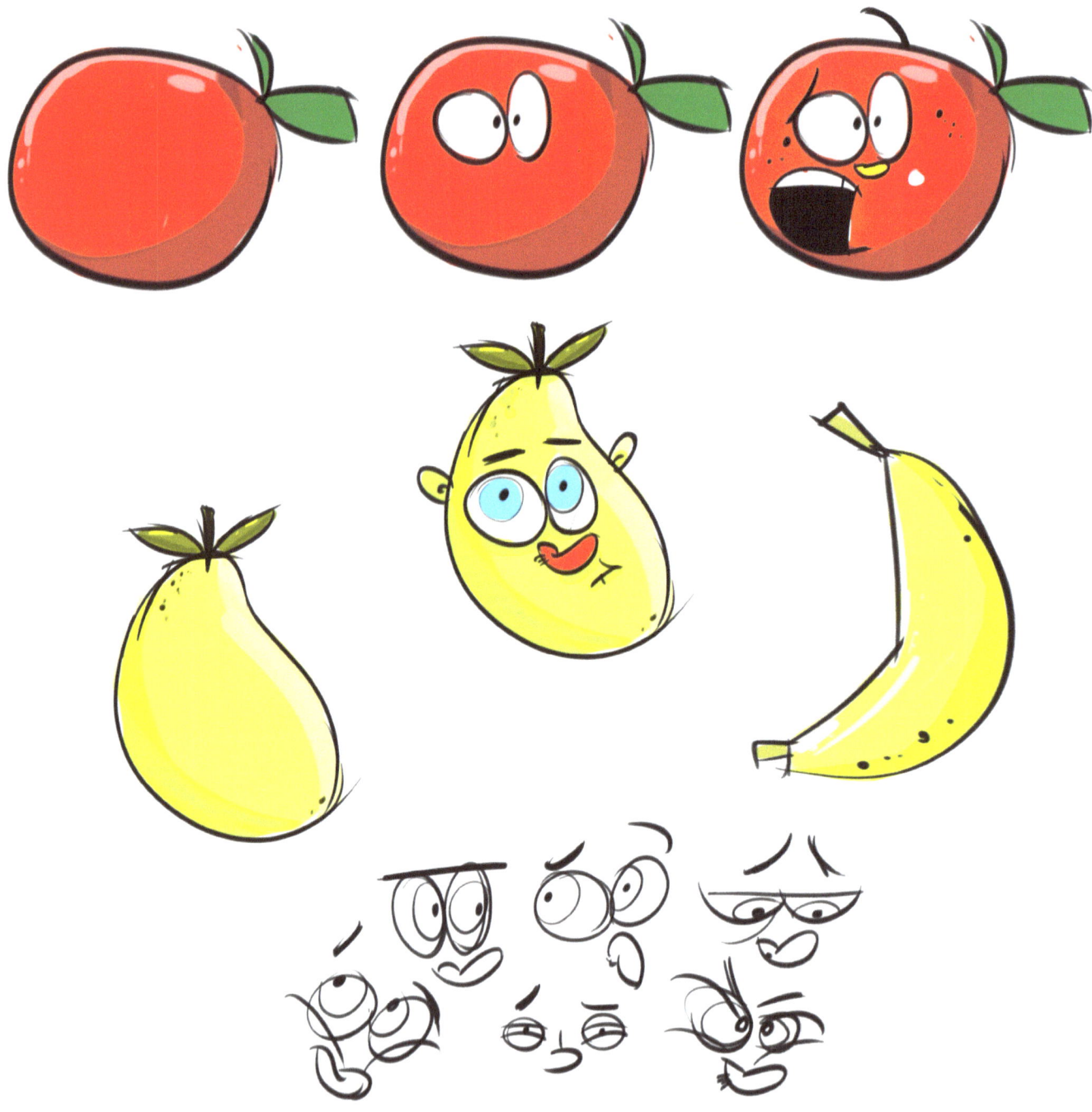

NINJAS VS WIZARDS

Your Mission

Ninja's Mr Worm and Mr Snail have stolen a secret talisman from Mr Wizard and he ain't happy! You will be designing a mini game to be played on your tablet (iOS or ANDROID) along with storyboards and comics to showcase your epic game and story.

Portal to Epic Game

Design your very own portal.

Extreme Ninja Specialists

Mr Worm Mr Snail

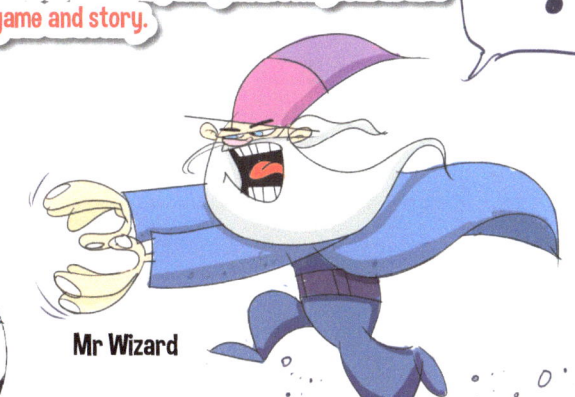

Mr Wizard

NINJA GAME DESIGN

Create Epic Game

Step 1: Storyboard your sequence
Step 2: Design a level for your characters to run through
Step 3: Complete the comic in this project

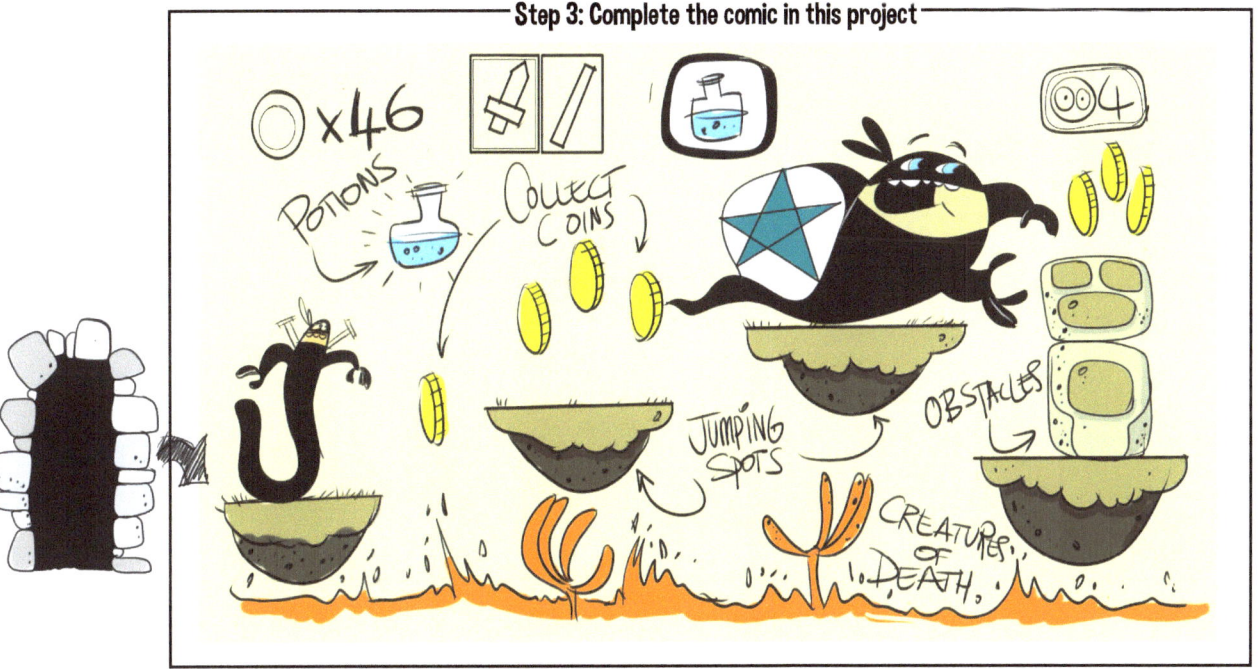

NINJA STORYBOARD

Develop an epic storyboard sequence that goes from a comic and then ends in your game, below is my EPiC version!

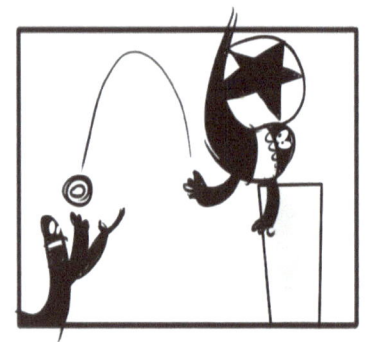 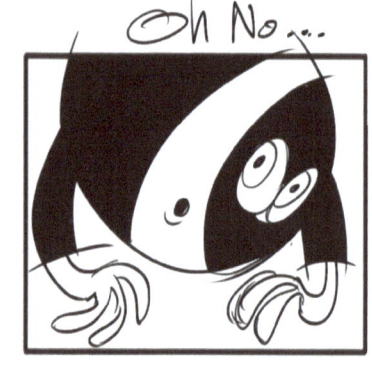

Oh No...

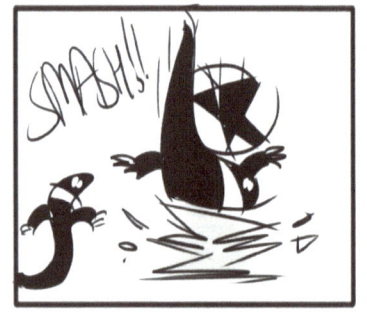 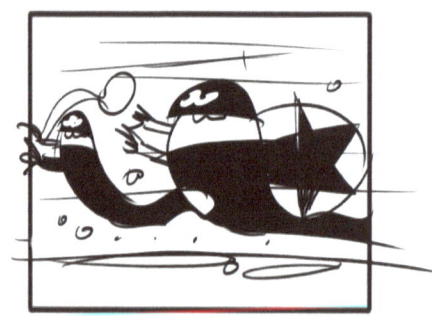

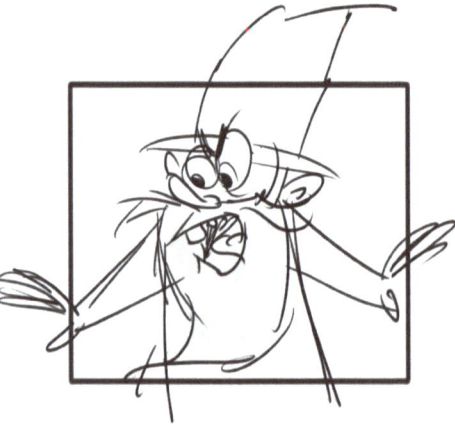 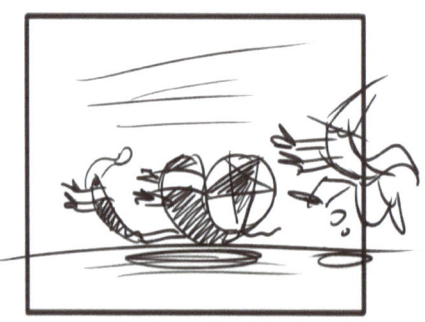 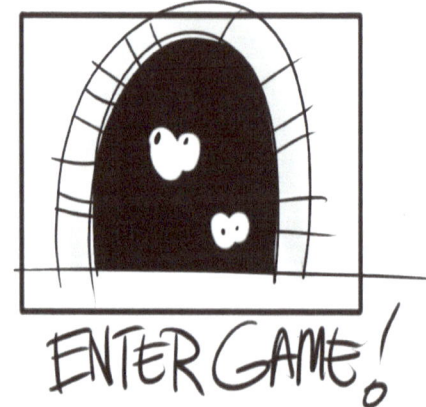

ENTER GAME!

NINJA COMIC DESIGN

Use your massive storyboard skills to create a comic master piece, choose any part of the storyboard to use, or just finish off my creation.

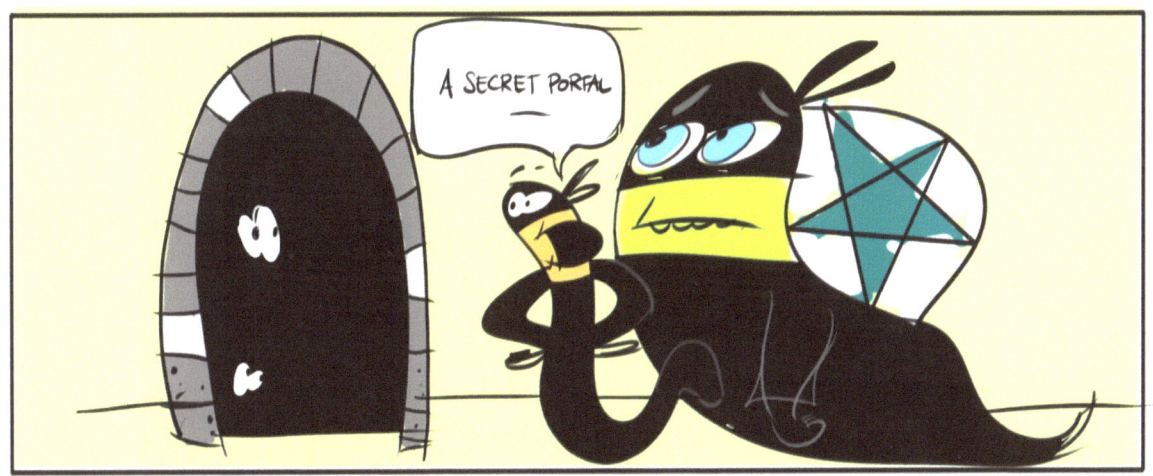

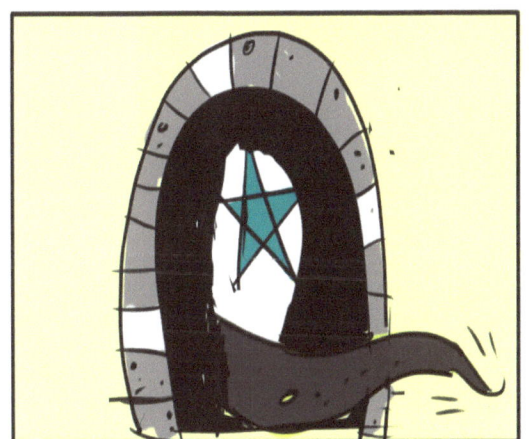

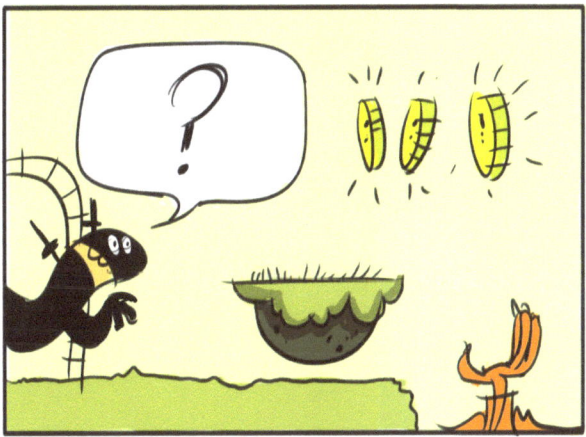

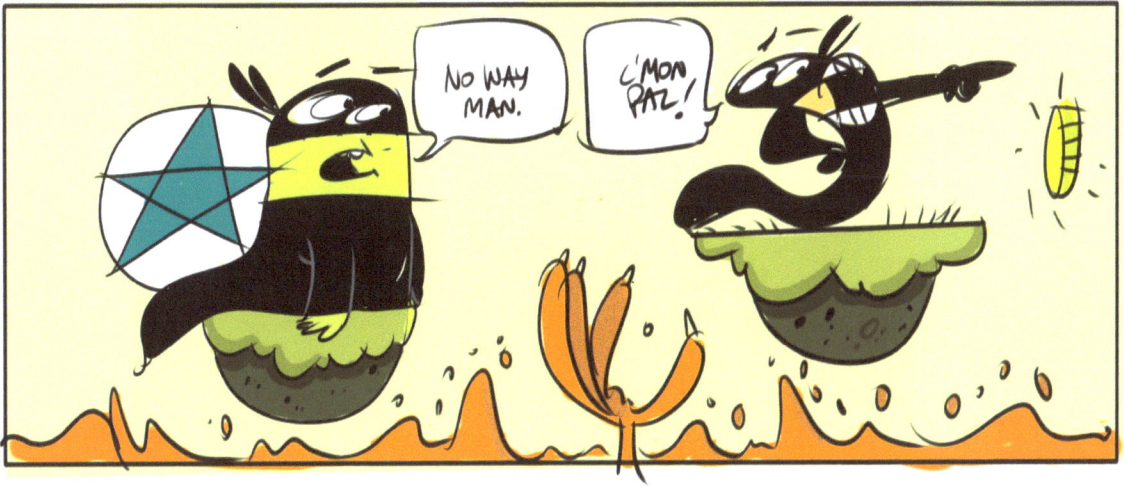

DRAW NiNJA SNaiL

Ninja Snail needs to be drawn!

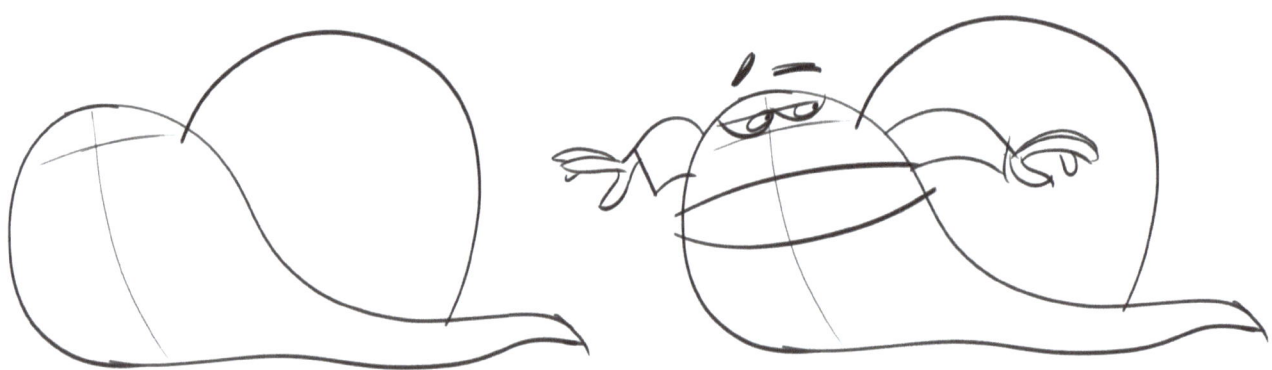

Begin Ninja Snail with his body and ninja house.

Add some ninja arms, eyes and clothes.

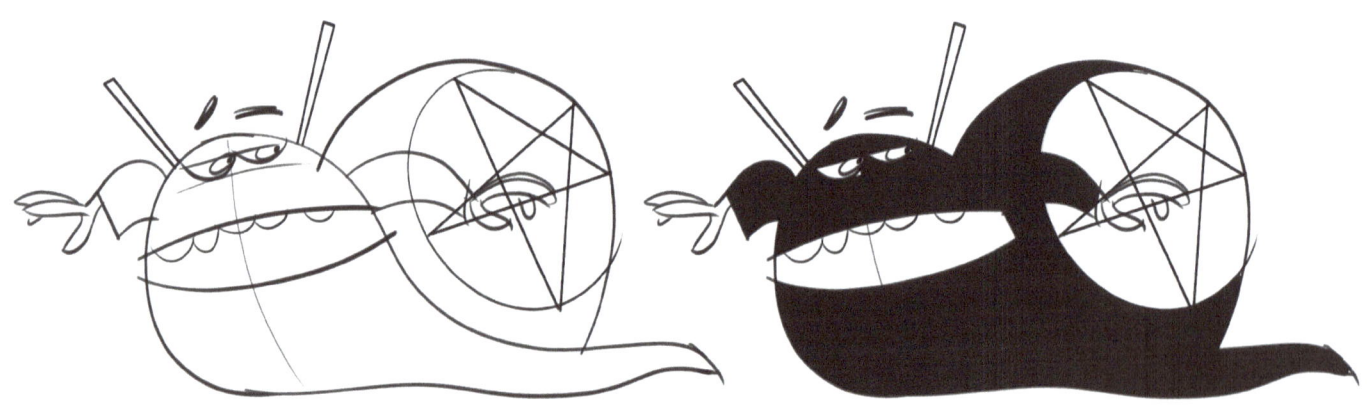

Throw in some ninja sticks, teeth and logo on his ninja house.

Add a dash of black. Nice.

TRANSPORT
TAXi

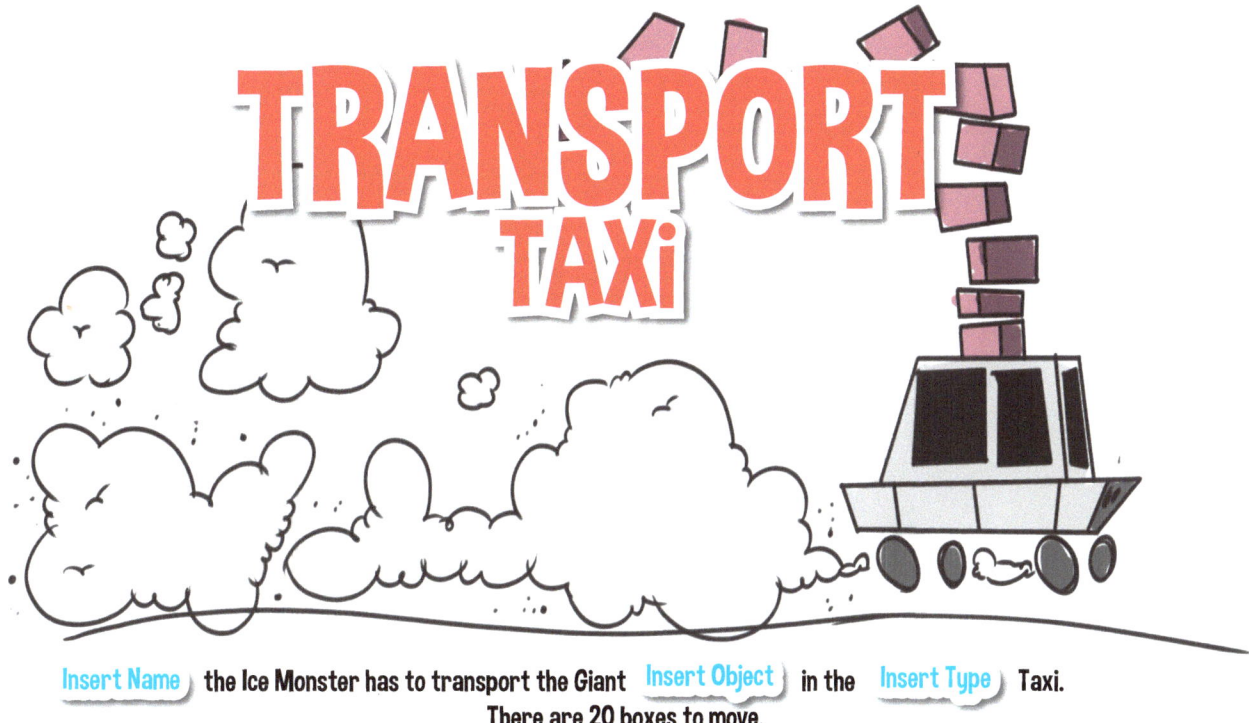

[Insert Name] the Ice Monster has to transport the Giant [Insert Object] in the [Insert Type] Taxi. There are 20 boxes to move.

Challenge: Insert your ideas where stated, then have a go at drawing them using the inspiration provided.
Extreme Challenge: Draw your character "stuffed" into the taxi, with 20 suitcases wobbling on top and your "objects" falling out of them.

NAMES
Beavis, Pickles, Sasquash, Romeo, Stan, Joe, Flatbush, Hairy Harry

TAXi TYPES
Evil, long, small, clown, chicken, floating, slow, snail, ice cream, happy, smooth, flying, angry, invisible.

OBJECTS
Eyeballs, sausages, feet, lips, noses, hamburgers, golf balls, marshmellows

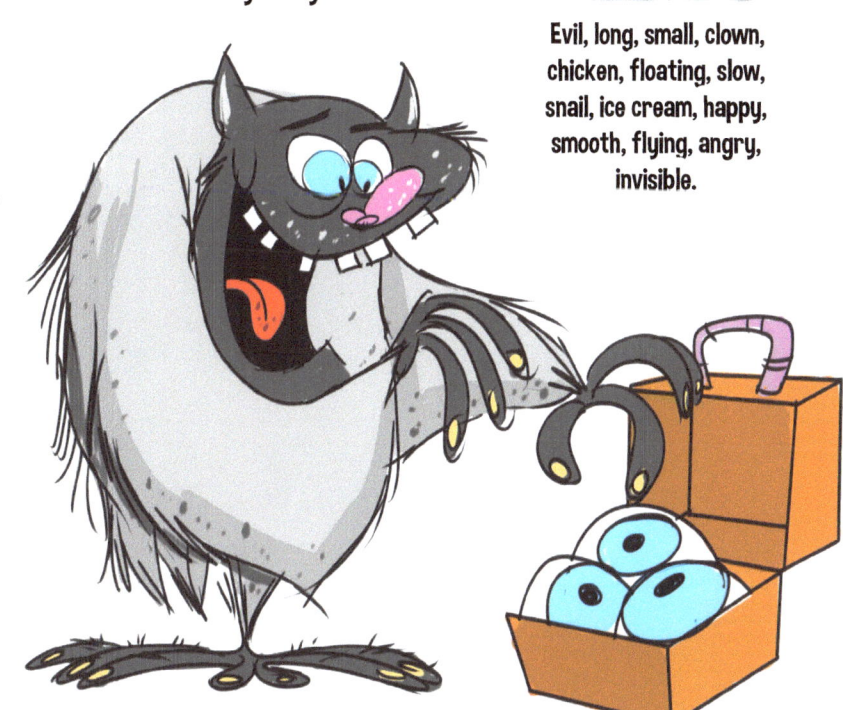

TAXI COMIC

Your Ice Monster has just ran out of petrol, boo hoo. Finish off this last panel.
Fancy a challenge? Then add another page to this already awesome comic.

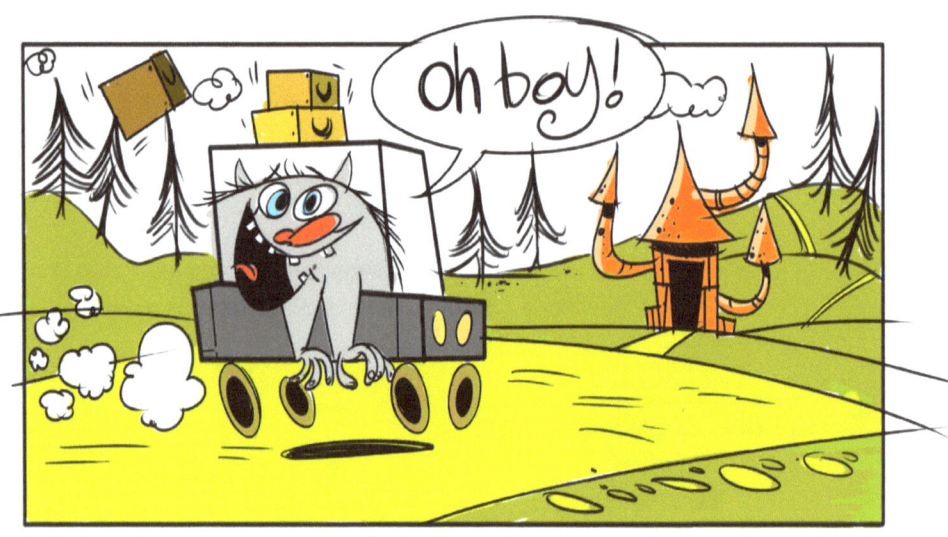

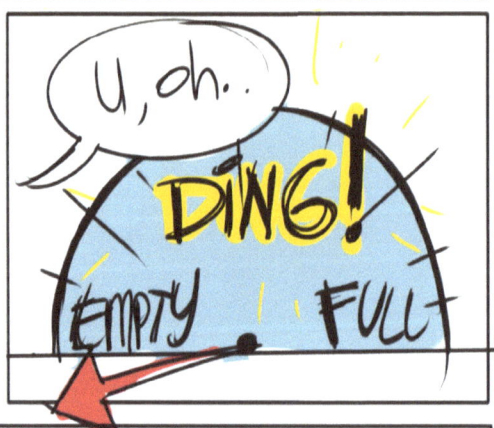

What happen's next?

Finish off this last panel with your awesome idea!
Ideas to draw: Petrol station, monster kebab, large rock.
Challenge of Extreme Awesomeness. Create page #2.
Xtra Challenge of Awesomeness. This panel must include
one of the following: Flashlight, mirror, kleenex.

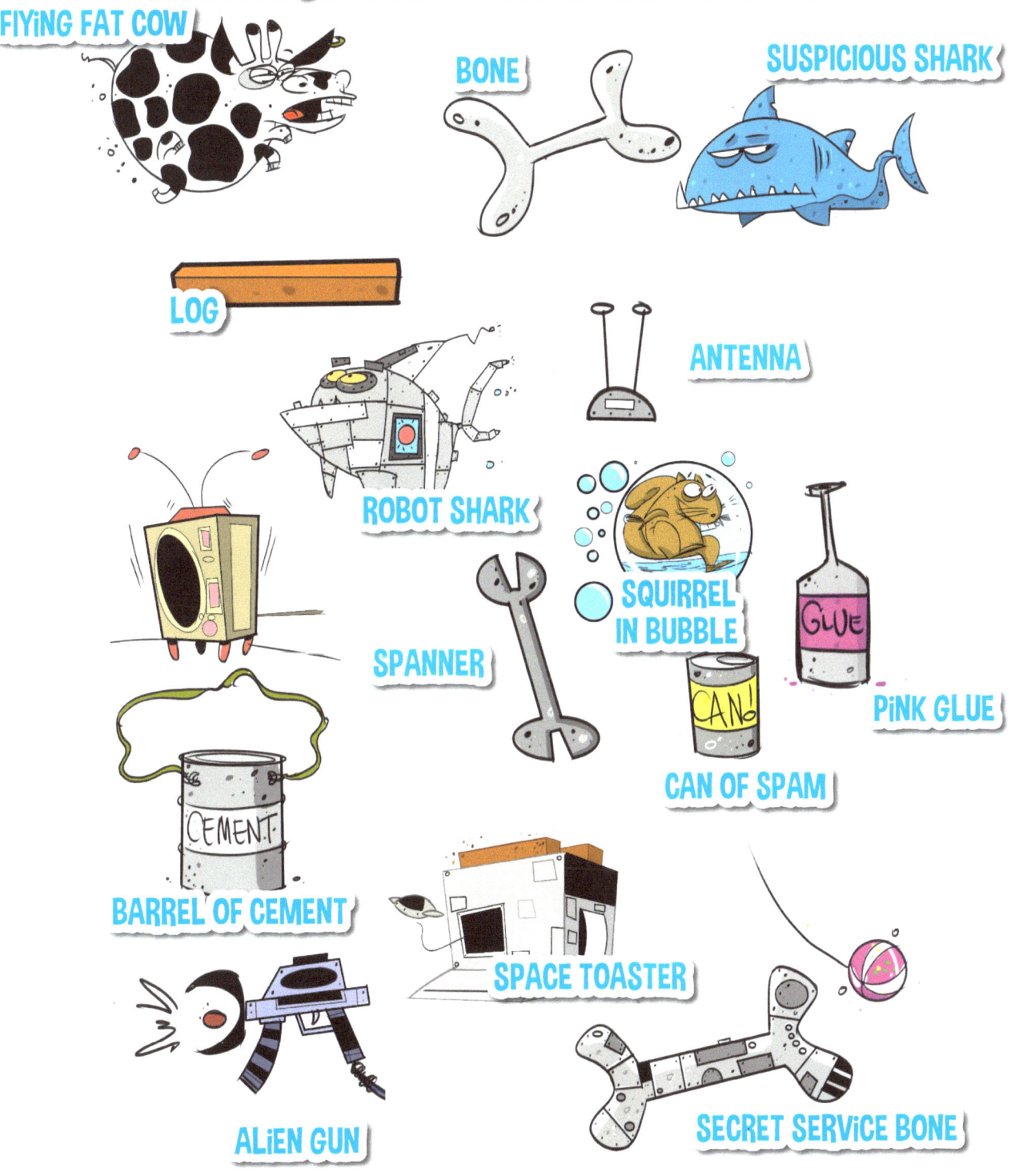

LET'S DRAW [insert name] iCE MONSTER
Make him extra furry!

Begin your ice monster with the above shapes

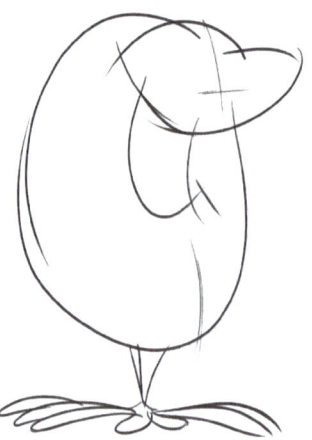

Draw in a nice big oval for the torso and add legs/feet.

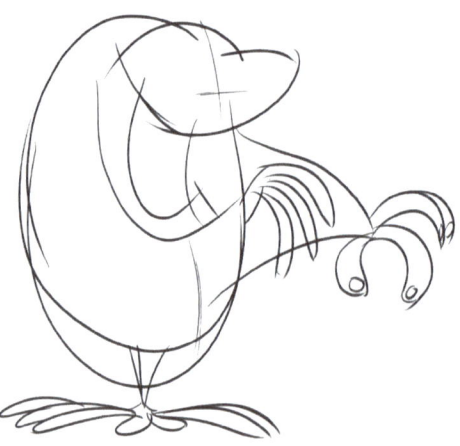

Next add your arms and hands.

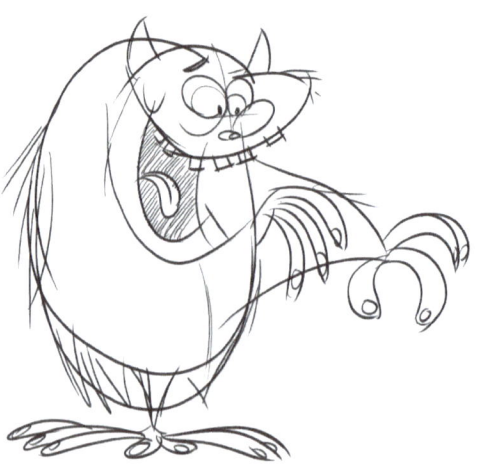

Finish off with facial details and fur.

www.ingramcontent.com/pod-product-compliance
Lightning Source LLC
Chambersburg PA
CBHW050401180526
45159CB00005B/2108